CREATE

Lawrence Rinder, with Matthew Higgs

Texts by Kevin Killian

UNIVERSITY OF CALIFORNIA, BERKELEY ART MUSEUM AND PACIFIC FILM ARCHIVE

cirrus clouds

cumulus clouds

nimbus clouds

stratus clouds

June July August

Aries Taurus Cancer Leo Virgo Libra Scorpia December January F
Gemini Sagittarius Capricorn
spring summer autumn winter
long days and short nights short days and long nights

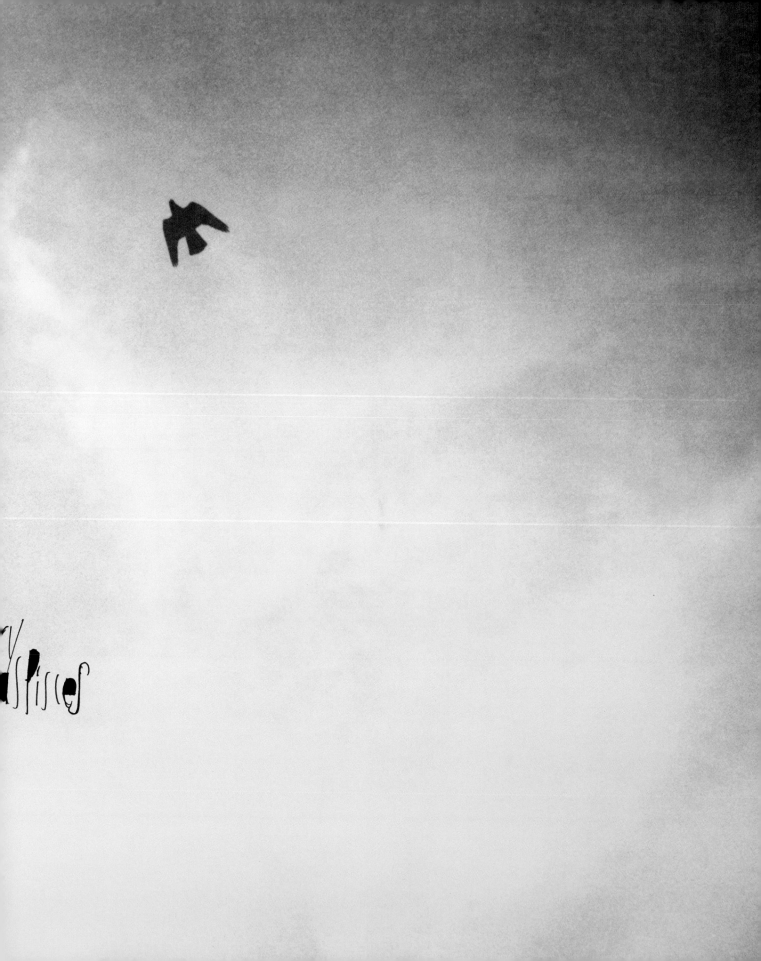

Create, curated by BAM/PFA Director Lawrence Rinder, with Matthew Higgs, director of White Columns, New York, is on view at the University of California, Berkeley Art Museum and Pacific Film Archive from May 11 to September 25, 2011.

Create has been made possible in part by Dr. James B. Pick and Dr. Rosalyn M. Laudati, the LEF Foundation, and the continued support of the BAM/PFA Trustees.

AC 18 '11

© 2011 by The Regents of the University of California, Berkeley

Published by the University of California, Berkeley Art Museum and Pacific Film Archive, Berkeley, California

Available through D.A.P./Distributed Art Publishers
155 Sixth Avenue, Second Floor, New York, NY 10013
Tel: (212) 627-1999

Book Design by Mary Kate Murphy

Library of Congress Cataloging-in-Publication Data

Rinder, Lawrence.

Create / Lawrence Rinder with Matthew Higgs ; texts by Kevin Killian.

p. cm.

Catalog of an exhibition on view at the University of California, Berkeley Art Museum and Pacific Film Archive, May 11–Sept. 25, 2011.

ISBN 978-0-9719397-9-0 (alk. paper)

1. Art, American—California—San Francisco Bay Area—Exhibitions. 2. Artists with mental disabilities—California—San Francisco Bay Area—Exhibitions. I. Higgs, Matthew. II. Killian, Kevin. III. Berkeley Art Museum and Pacific Film Archive. IV. Title.

N6535.S3R56 2011

704'.0870973—dc22

2011006026

Printed in China

A national tour of *Create* is being organized by Independent Curators International.

Independent Curators International (ICI) produces exhibitions, events, publications, and training opportunities for diverse audiences around the world. A catalyst for independent thinking, ICI connects emerging and established curators, artists, and institutions, to forge international networks and generate new forms of collaboration. Working across disciplines and historical precedents, the organization is a hub that provides access to the people, ideas, and practices that are key to current developments in the field, inspiring fresh ways of seeing and contextualizing contemporary art.

Cover: FIGURE 74
Evelyn Reyes: *Garbage Cans* (detail), 2004; oil pastel on paper; 11 ¼ × 17 ⅝ in.; courtesy of the artist and Creativity Explored, San Francisco.

Frontispiece: FIGURE 39
John Patrick McKenzie: *Cirrus Clouds*, 2010; Sharpie marker on Felix Gonzalez-Torres poster; 29 ¼ × 44 ¼ in.; courtesy of the artist and Creativity Explored, San Francisco.

Page 6: FIGURE 85
Lance Rivers: *Train Tunnel Landscape* (detail), 2009; ink and watercolor on mat board; 5 × 7 in.; collection of Leeza Doriean and John Phillips, San Francisco.

Page 8: FIGURE 10
Jeremy Burleson: *Ventilator*, 2007–2010; paper, tape, and marker; 8 × 12 × 5 in.; courtesy of NIAD Art Center, Richmond, CA.

Page 176: FIGURE 54
James Montgomery: *Watches on Orange* (detail), 2007; correction fluid pen, ink, and acrylic on paper; 22 × 30 in.; courtesy of Creativity Explored, San Francisco

Page 178: FIGURE 49
Dan Miller: *Untitled (Large Works DM10)*, c. 2010; mixed media on paper; 40 × 60 in.; courtesy Ricco/Maresca Gallery, New York.

Page 180: FIGURE 98
William Scott: *Girlfriend Is Back (Donna King)*, n.d.; acrylic on paper; 20 × 15 in.; collection of Cindy Sherman, New York.

Contents

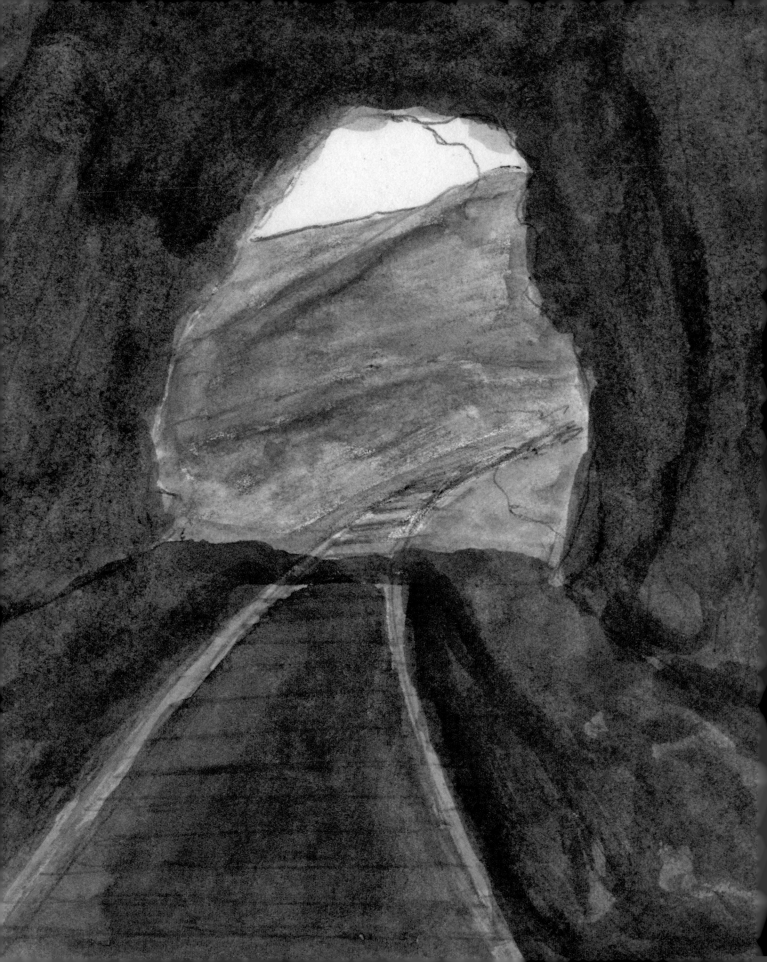

Foreword

The University of California, Berkeley Art Museum and Pacific Film Archive is proud to present exhibitions and film series that are characterized by excellence and edge. We always present extraordinary art but we take particular pride in seeing art where others may not have seen it before and thereby reshaping the parameters of contemporary culture. *Create* is a perfect case in point. The artists in this exhibition—who all have some form of developmental disability—possess the level of talent, independence, and depth of feeling that makes the most powerful art possible. Yet, as disabled artists, their work has not been widely seen. Through the work of three pioneering Bay Area centers for arts and disability—Creative Growth Art Center, Creativity Explored, and the National Institute of Art and Disabilities (NIAD Art Center)—their status as outsiders is rapidly shifting to that of insiders. We are tremendously honored to be playing a role in that transformation.

First and foremost, our heartfelt thanks go to the artists themselves, whose work has inspired so many, artists and art lovers alike. We are very grateful to the staffs of Creative Growth Art Center, Creativity Explored, and NIAD Art Center, and especially to their executive directors, Tom di Maria, Amy Taub, and Deborah Dyer, who have been so helpful throughout the planning process. We would also like to thank Brian Stechschulte, gallery director at NIAD Art Center; Amy Auerbach, gallery manager at Creativity Explored; and Jennifer Strate O'Neal, curator and gallery manager at Creative Growth, for their valuable assistance. Furthermore, we extend our deep thanks to the inspired staffs of all three organizations who have so wonderfully supported the efforts of the artists included in the exhibition.

Many thanks to Matthew Higgs for his selection of works from Creative Growth Art Center. Even in advance of this exhibition, Matthew has done an amazing job of bringing this work to the attention of a wider arts community. Kevin Killian's texts have illuminated the work of each artist in a wonderfully personal way. Sincere thanks go to Kate Fowle and Fran Wu Giarratano at Independent Curators International, New York, for recognizing the importance of this exhibition and organizing a national tour, which will follow the Berkeley presentation of *Create*.

I am honored to acknowledge the insight and talents of the BAM/PFA staff, whose work has brought all of the many threads of this project together so marvelously. While the entire staff has worked towards the success of *Create*, I would like to give special thanks to Stephanie Cannizzo, Nina Lewallen Hufford, Mary Kate Murphy, Karen Bennett, Doug McCallister, Barney Bailey, Pam Pack, Benjamin Blackwell, Peter Cavagnaro, Elisa Isaacson, Lisa Calden, Gary Bogus, Scott Orloff, Laura Hansen, Michael Meyers, and Lupe Gomez-Downing for their important contributions.

We are grateful to the many lenders who have agreed to part with their precious works for the Berkeley exhibition and extended tour. And finally, thanks to our funders, Dr. James B. Pick and Dr. Rosalyn M. Laudati and the LEF Foundation, whose generous support has made this exhibition possible.

Lawrence Rinder
DIRECTOR

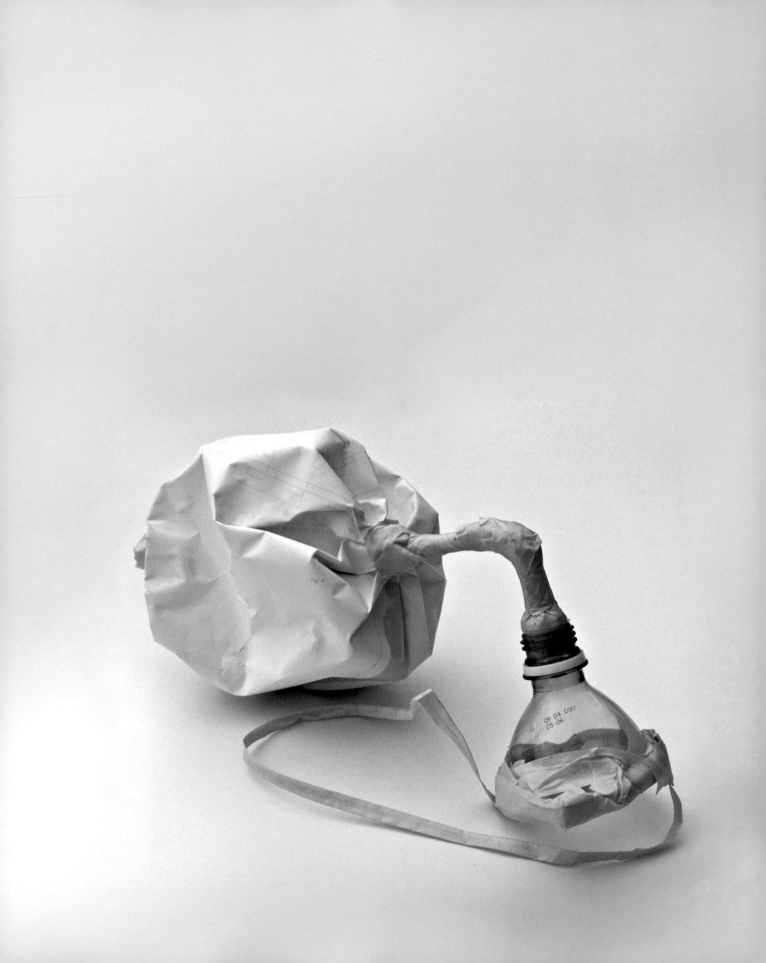

Create

LAWRENCE RINDER

It's hard to say why great art happens when it does. Is it a result of innate talent, professional training, material support, and the opportunity to focus? Even more compelling is the question of why art sometimes flourishes in concentrated communities. Why were there such extraordinary periods of collective art making at Black Mountain College in the 1930s, 1940s, and 1950s; in the tiny community of Gee's Bend, Alabama, in the mid-twentieth century; or in the communal squat known as Fort Thunder in Providence, Rhode Island, in the late 1990s? Over the past thirty years there has been just such an outpouring of concentrated creative energy at three Bay Area centers for artists with developmental disabilities: Creative Growth Art Center in Oakland; National Institute of Art and Disabilities (known as NIAD Art Center) in Richmond; and Creativity Explored in San Francisco.

While they are independent and have only rarely collaborated, the institutions have a shared history: all three were founded by two pioneers of the art and disabilities movement, Florence Ludins-Katz and Elias Katz. In the 1970s, the Katzes developed an innovative new methodology for supporting artists with developmental disabilities. Their approach focused on a group studio environment, professionalism, and engagement with the broader art community. The progressive, inclusive social environment of the Bay Area facilitated the Katzes' vision by providing many opportunities for involvement with practicing artists as well as a welcoming audience—and collectors—for the work made in each studio. The centers offer an experience that is, in many ways, the antithesis of that envisioned by the art critic Roger Cardinal in 1972 when he coined the term "outsider art" to identify the work of artists who have no contact with the art world and who are physically and/or mentally isolated.[1] By contrast, the artists at the three Bay Area centers work alongside one another, create new works specifically for exhibition and sale, make frequent visits to local galleries and museums, and have regular access to artist mentors who assist them in developing new approaches and techniques.

The atmosphere of the centers' studios is inspiring to just about anyone who happens to come in, and the studios are open to visitors during their regular working hours. There is a quiet yet palpable excitement, as some artists are absorbed in solitary art making while others share their recent work, relax, listen to music, or greet the incoming guests. More than one artist from the broader community has told me they wished there were such communal studios for nondisabled artists. Clichés about how art by the disabled looks are quickly dispelled when confronted by the tremendous diversity of styles and approaches being deployed. Figurative, abstract, and text-based approaches coexist and, at times, influence one another.

The work made by artists at these centers has inspired and influenced many others in the wider community. Art made at San Francisco's Creativity Explored, for example, resonated with other streams of influence, including graffiti, vernacular sign painting, and Mexican-tradition murals, to influence the distinctively informal, imaginative, and colorful style of art that came to be known by the term "Mission School."[2] The significant engagement of many San Francisco artists as staff and volunteers has been essential to Creativity Explored's broad impact.[3] Similarly, at both Creative Growth and NIAD Art Center, the centers' artists are mentored not by therapists but by practicing professional artists.[4] At all three centers, professional artists have collaborated on works of art and have also been involved in curatorial projects, such as the recent exhibition *Rare and Unreleased*, organized for NIAD Art Center by Timothy Buckwalter and co-curated by artists John Zurier, Cliff Hengst, and Helena Keeffe, among others. Oakland's Creative Growth Art Center has developed the most national and international art-world connections, with the work of many of its artists entering important collections, including those of prominent artists such as Cindy Sherman, Jeremy Deller, Chris Ofili, and Peter Doig. Creative Growth has also been operating a gallery in Paris, further extending its influence to the European continent.

• • •

The profoundly engaged practices supported by these centers are a result, in part, of dramatically changed attitudes towards disability. Indeed, definitions of developmental disability and attitudes towards art and disability have changed tremendously over the centuries. Today, for example, there is a clear distinction between developmental disability and mental illness: the former indicates a lifelong mental and/or physical disability with onset before the age of twenty-two, while the latter indicates a medical condition with onset occurring at any age. Symptoms of mental illness can frequently be managed with a combination of medications and psychotherapy.[5] However, before the late twentieth century such distinctions were uncommon and people who would now be differentiated were often categorized simply as mad or insane. Whether their mental condition existed from birth or not, individuals with mental disabilities were outcasts whose "madness" was associated with everything from witchcraft and social transgression to artistic genius.

Consider the case of the English autodidact John Clare (1793–1864), a writer celebrated for his extraordinarily detailed observational essays and poetry. Clare was confined to an asylum for the last decades of his life; at the time, one view held that his supposed madness was the inevitable result of the conflict between his peasant upbringing and his literary and social aspirations (that is, evidence of a violation of the "natural" social order), while his biographer, Jonathan Bate, suggests that Clare's poetic disposition may itself have been the original cause of his being indentified as insane: "In summer he walked in the woods and fields alone, a book in his pocket . . . the villagers found this behavior very odd: 'some fancying it symptoms of lunacy.'"[6] Was Clare "developmentally disabled" or "mentally ill"? Or was he simply a poetic, slightly eccentric man who dared to challenge the social castes and norms of his day?

While scientific advances in the nineteenth century brought an increasing recognition that mental disorders often have biological causes, there was also—in line with the Romantic Movement's emphases on inner experience and nonconforming social behavior—a growing belief that those with mental disabilities were endowed with special creative powers. In his 1812 text *Medical Enquiries and Observations upon the Diseases of the Mind*, Benjamin Rush observed that mental aberrations could reveal hitherto unrealized artistic capacities, bringing to the surface "precious and splendid fossils, the existence of which was unknown to the proprietors of the soil in which they were buried."[7] In the mid-twentieth century, artists with mental disorders were celebrated both for their unique access to internal worlds (often understood in psychoanalytic terms) as well as for the "purity" of their existence, that is their production of art outside of the supposedly contaminated channels of art-world promotion. As Jean Dubuffet, the most influential champion of art made by the mentally disabled, wrote:

> Those works created from solitude and from pure and authentic creative impulses—where the worries of competition, acclaim, and social promotion do not interfere—are, because of these very facts, more precious than the productions of professionals. After a certain familiarity with these flourishings of an exalted feverishness, lived so fully and so intensely by their authors, we cannot avoid the feeling that in relation to these works, cultural art in its entirety appears to be the game of a futile society, a fallacious parade. [8]

With only a few exceptions, the appreciation of work by artists with developmental disabilities and mental illness has been in the form of distanced admiration and occasional imitation (as in Dubuffet's own work): it has not extended to the acceptance of these artists as full-fledged members of the cultural community. Indeed, according to Dubuffet, it could not, by definition, do so.

American perceptions of people with disabilities began to change in the 1960s, a shift that ultimately had a powerful impact on the understanding of the relationship between developmental disability/mental illness and creativity. This transformation saw the emergence of a legal framework for embracing all people—regardless of ability—as equal citizens, entitled to the same rights and protections. In 1973, Congress passed the Rehabilitation Act, which for the first time gave legal protections to disabled individuals, prohibiting discrimination by federal agencies and contractors on the basis of disability.[9] Also in 1973, the California Legislature passed the Lanterman Developmental Disabilities Act, giving people with developmental disabilities the right to the services necessary to lead a normal, independent life. Significantly, this bill required that "the state shall contract with appropriate agencies to provide fixed points of contact in the community for persons with developmental disabilities and their families, to the end that these persons may have access to the services and supports best suited to them throughout their lifetime."[10] Thus, the Lanterman Act established the foundation for ongoing state support of nonprofit, nongovernmental community organizations like Creative Growth, Creativity Explored, and NIAD Art Center.

The disabilities movement, which grew out of the mass deinstitutionalizations of the 1950s and 1960s, was already underway in the Bay Area when Florence Ludins-Katz and Elias Katz moved to Berkeley in 1966. Florence was an artist and had taught at both the high school and college levels; Elias had been a staff psychologist at the Sonoma State Home for the Mentally Retarded. Their independent work with artists began spontaneously when they invited a number of artists with developmental disabilities to their home for an art-making event. Realizing the potential of this interaction, they moved the gathering into its own facility so that the creative work could continue every

day. A National Endowment for the Arts grant enabled them, in 1972, to establish the first institution devoted to artists with developmental disabilities, Creative Growth (the name was changed to Creative Growth Art Center in 1983), in Oakland.[11] The program's success led the Katzes in 1982 to start another studio, NIAD Art Center, in Richmond, which they hoped would become the home for a nationwide art and disabilities movement. In 1981, they founded Creativity Explored in San Francisco and Creativity Unlimited in San Jose (now defunct) followed in 1982. The same goals they had set in 1972 for Creative Growth were maintained for subsequent centers:

- The art center would be closely connected with the arts community and the art world.

- The studio space would be an "open studio" where the participating artists with developmental disabilities would be free to select their space to work, with freedom to create.

- Professional artists would be employed to encourage the artists with developmental disabilities to express themselves to the full extent of their creativity.

- An art gallery managed by a professional curator would exhibit and sell art by the artists with developmental disabilities.

- The art center would be full time, five days a week.

The Katzes believed that they had struck upon a uniquely successful model for working with artists with developmental disabilities, a model that could be replicated by others. Towards this end, they jointly authored *Art and Disabilities: Establishing the Creative Art Center for People with Disabilities,* in which they laid out their ideas in a manual-like format. In this book, they described their centers as fostering

> a full-time supportive and stimulating environment without pressure, threat, or competitiveness in which creative work in painting, sculpture, printmaking, creative crafts, etc., is carried on in a studio setting by people with mental, physical, and social disabilities.[12]

While the Katzes always envisioned that selling the artists' work would be an important dimension of the centers' practice and that there would be a close connection to the art world, they may not have anticipated just how visible—and valuable—the works made at their centers would become, phenomena that have at times conflicted with their aim of a noncompetitive environment.[13] Yet any competitiveness that exists among the artists—for sales, exhibition, or recognition—can be viewed as a sign of the success that these centers have had in integrating their artists into the larger art world, artistically as well as economically. One hundred and fifty years after the death of John Clare, they have become "insiders."

This transformation of developmentally disabled artists from "outsiders" to "insiders" is a key achievement of the Katzes' three centers. They have made possible the expansion of the community of artists by embracing, supporting, and exposing the work of people who have never been fully welcomed into the mainstream.

Is the achievement of these artists because of, or despite, their disabilities? The Romantics of the nineteenth century would have believed the former while the progressivist view of today would favor the latter opinion. However, I believe this unanswerable question needs to be set aside. The simple fact that so many people have made so much extraordinary art together is more than enough to warrant an exploration and celebration of their work. As in other instances in which small communities became powerhouses of creativity, Creative Growth Art Center, Creativity Explored, and NIAD Art Center have fostered an atmosphere in which competition takes a back seat to inspiration, in which convention is trumped by invention, and in which art is seen as essential to life.

Thanks to Samantha Frank for her helpful research.

Notes

1 Roger Cardinal, *Outsider Art* (London: Studio Vista, 1972).

2 Glen Helfand, "The Mission School," *San Francisco Bay Guardian*, January, 12, 2002, http://www.sfbg.com/36/28/art_mission_school.html.

3 Among the artists who have worked as staff or volunteered at Creativity Explored are: Miranda Bergman, Chuy Campusano, Victor Cartagena, Harrell Fletcher, Susan Greene, Ester Hernandez, Chris Johanson, Aaron Noble, Ray Patlan (Creativity Explored's first executive director), Alison Pebworth, and Horace Washington.

4 Among the artists who have worked as staff or volunteered at Creative Growth are: Joan Brown, David Byrne, Squeak Carnwath, Ann Collier, Mark di Suvero, Peter Doig, Cheryl Dunn, Reanne Estrada, Michael Hall, Marc Jacobs, Naomie Kremer, Emmanuel Montoya, Dave Muller, Manuel Neri, Laura Owens, Stan Peterson, Rob Reger, Cindy Sherman, Tara Tucker, and Ann Weber. Artists who have worked with NIAD include: Timothy Buckwalter, Bueno Castellano Maria, Judy Dater, Betty Friedman, Hugh Shurley, and John Toki.

5 The term "developmental disability" first appeared in U.S. law in *The Developmental Disabilities Services and Facilities Construction Act of 1970*, Public Law 91–517, *U.S. Statutes at Large* 84: 1316. The current federal definition of developmental disability appears in the *Developmental Disabilities Assistance and Bill of Rights Act of 2000*, *U.S. Code* 42, sec. 6001. It reads, in part:

> (A) IN GENERAL. The term "developmental disability" means a severe, chronic disability of an individual that
> (i) is attributable to a mental or physical impairment or combination of mental and physical impairments;
> (ii) is manifested before the individual attains age 22;
> (iii) is likely to continue indefinitely;
> (iv) results in substantial functional limitations in 3 or more of the following areas of major life activity: (I) Self-care; (II) Receptive and expressive language; (III) Learning; (IV) Mobility; (V) Self-direction; (VI) Capacity for independent living; (VII) Economic self-sufficiency; and
> (v) reflects the individual's need for a combination and sequence of special, interdisciplinary, or generic services, supports, or other assistance that is of lifelong or extended duration and is individually planned and coordinated.

6 Jonathan Bate, *John Clare: A Biography* (New York: Farrar, Straus, and Giroux, 2003), 28.

7 Benjamin Rush, *Medical Enquiries and Observations upon the Diseases of the Mind* (Philadelphia: Kimber & Richardson, 1812), 154.

8 Jean Dubuffet, "Place à l'incivisme," *Art and Text* 27 (December 1987–February 1988), 36.

9 *Rehabilitation Act of 1973*, Public Law 93–112, 93rd Cong. (September 26, 1973).

10 Lanterman Developmental Disabilities Act (AB 846), section 4620. The 1973 Lanterman Act was a significant revision and expansion of the landmark 1969 Lanterman Mental Retardation Services Act (AB 225).

11 One of the very few precedents was an art center for adults with disabilities that was founded in 1968 by Ms. Wilmer James at the Exceptional Children's Foundation in Los Angeles. The Katzes learned about this center only after establishing Creative Growth. http://www.communityarts.net/readingroom/archivefiles/2002/02/art_centers_for.php

12 Florence and Elias Katz, *Art and Disabilities: Establishing the Creative Art Center for People with Disabilities* (Cambridge, MA: Brookline Books, 1990).

13 In interviews conducted on May 11 and 12, 2010, by BAM/PFA intern Samantha Frank, staff members Paul Moshammer at Creativity Explored and Stan Peterson at Creative Growth reported that some of the artists were competitive around issues of exhibition and sales.

Art and Artists

Texts by Kevin Killian

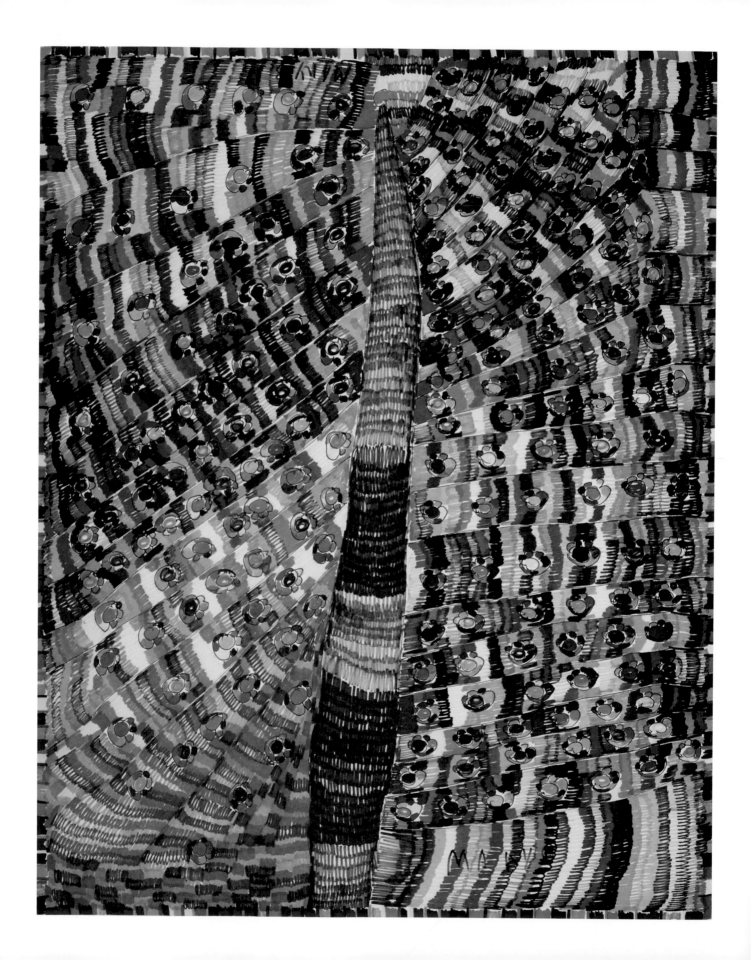

Mary Belknap

In an untitled piece from 2008 (fig. 1), Mary Belknap uses Sharpie pens and felt-tip markers to make thousands of tightly clustered dash-like marks that, in aggregate, suggest a glittering mosaic, iridescent plumage, or a wondrous, towering tree. Her spectral use of color seems to bend light itself, as her myriad hues curve around a dark central axis. Like the pointillist Georges Seurat, Belknap grows her creations from tiny units of visual information; like her contemporary Bridget Riley, she repeats her gestures and forms in variations that crest in waves and give the illusion of movement. Her colors are like a box of marbles shaken, spilled onto paper, and affixed into a pattern of revelation.

In recent years, Belknap has experimented with a much more blanched and attenuated palette. Here, color takes a backseat to various types of mark making, balanced formally between repeated horizontals (we might imagine steps) and verticals (could they be tree trunks?). One piece from 2010 (fig. 5) reads like a deconstruction of her former style, incorporating a lexicon of various marks arrayed in horizontal bands. Works such as this convey a sense of serene contemplation, like Agnes Martin studying the simple horizon day after day and night after night.

FIGURE 1 17

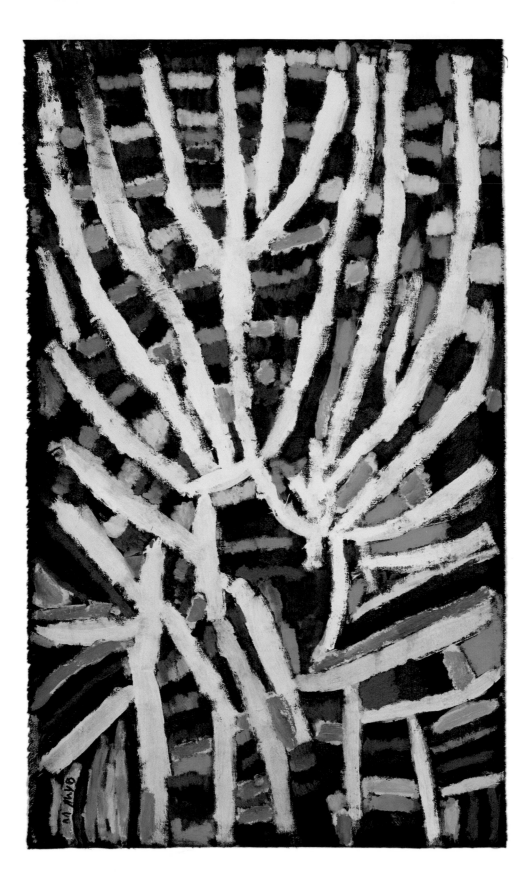

FIGURE 2

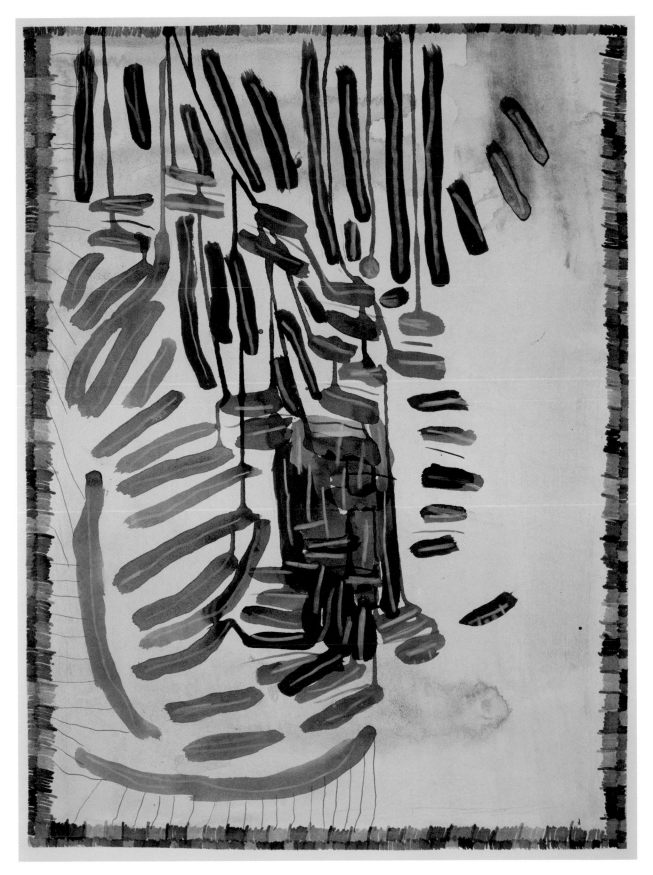

FIGURE 3 19

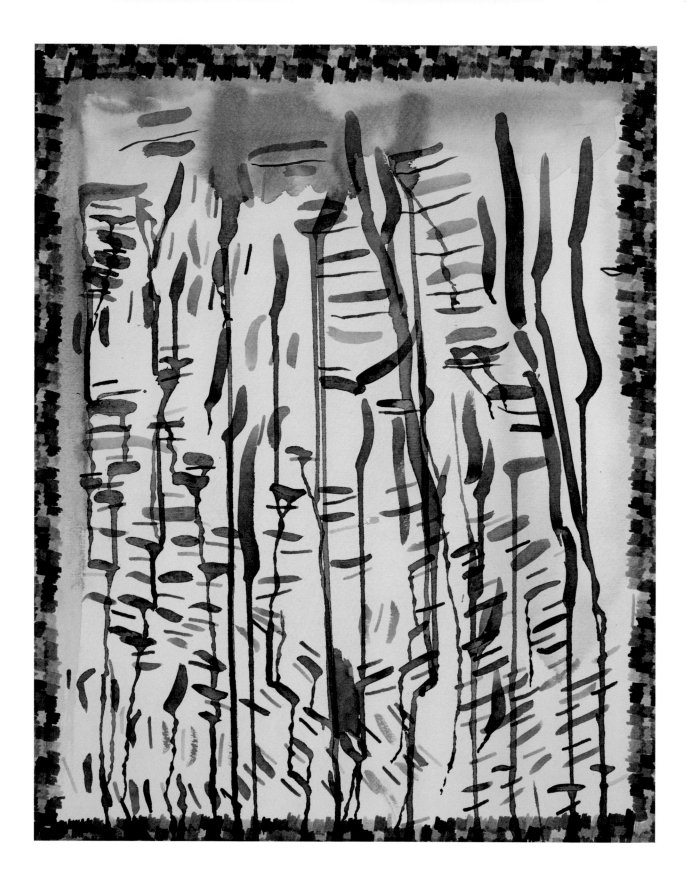

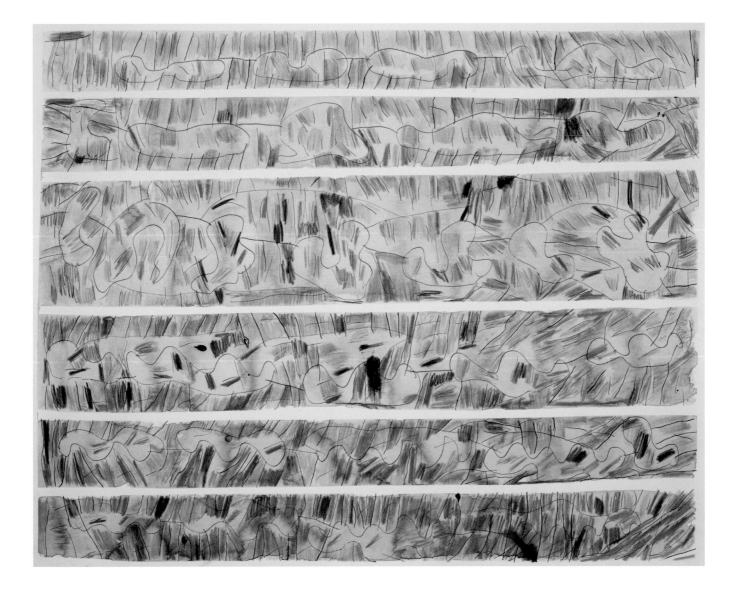

FIGURE 5 21

FIGURE 6

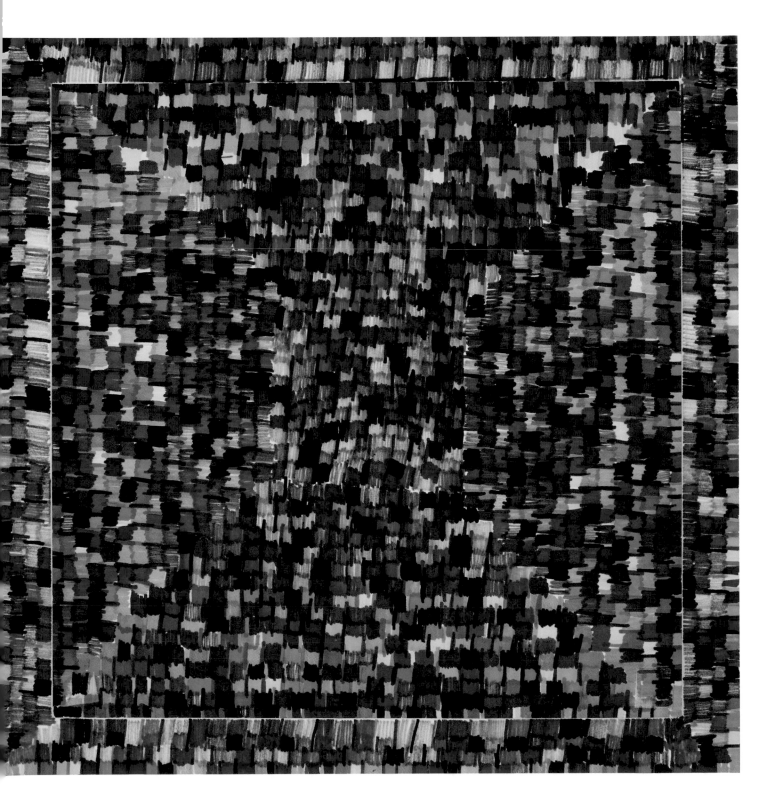

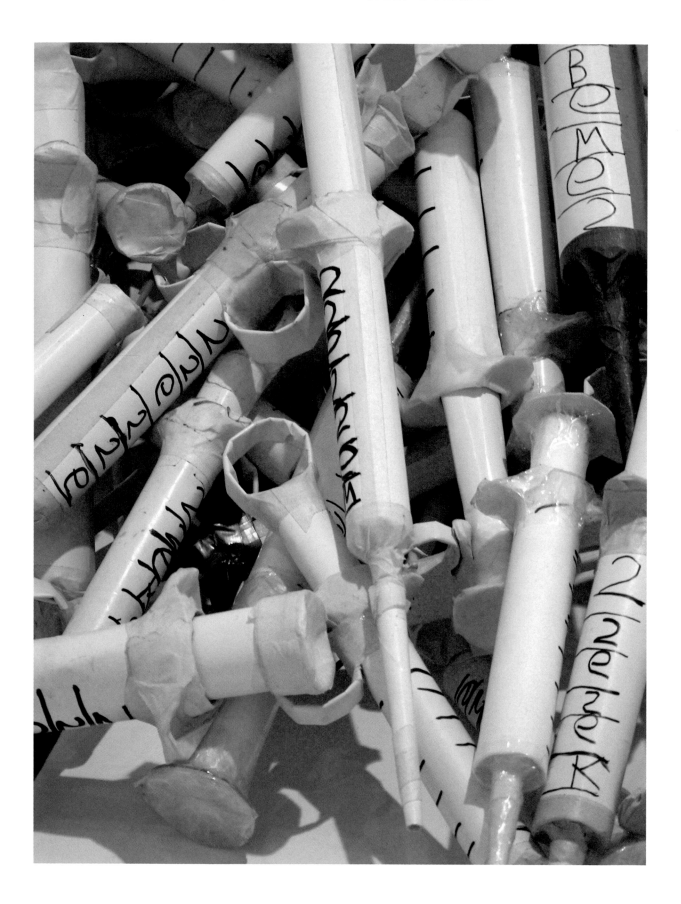

Jeremy Burleson

Jeremy Burleson's three-dimensional objects startle and delight. He chops and churns pieces of paper into intricately designed sculptural objects, which often take the form of medical devices. Another significant body of work mimics lamps—strange lamps, vaguely allegorical—perhaps the safety lamps of miners going all the way down to the forbidden zone (figs. 8, 9). Burleson's work exudes a Pop theatricality, as though he had studied with Robert Rauschenberg, Claes Oldenburg, or Red Grooms; like his older colleagues, Burleson has mastered the sinuous and shifty relationship among design, expression, and abstraction.

His hypodermic needles (figs. 7, 8), with that dismal oatmeal color they use in masking tape set off by brightly colored tips, look as though they might actually work, but what shall we fill them with and whom shall we stick them into? His ventilators, meanwhile, evoke the queasy reality of the suffering asthmatic (fig. 10). And those delicately crafted, sometimes cheerfully colored handcuffs (fig. 11)! It is all quite theatrical, the thrilling props of medicine and the law.

FIGURE 7 25

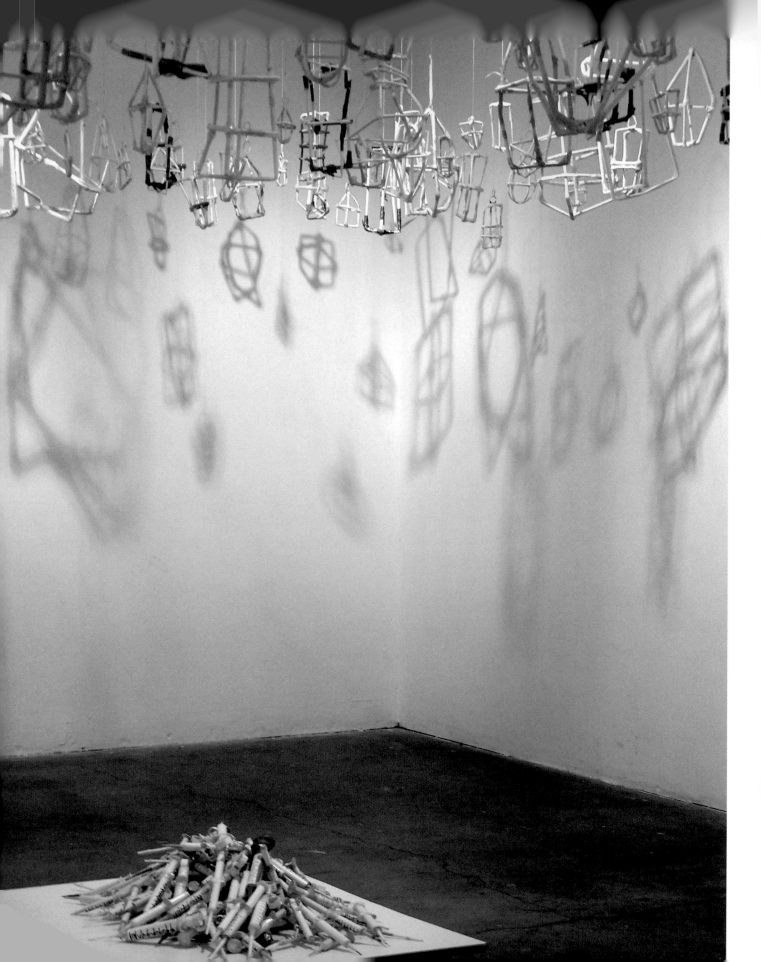

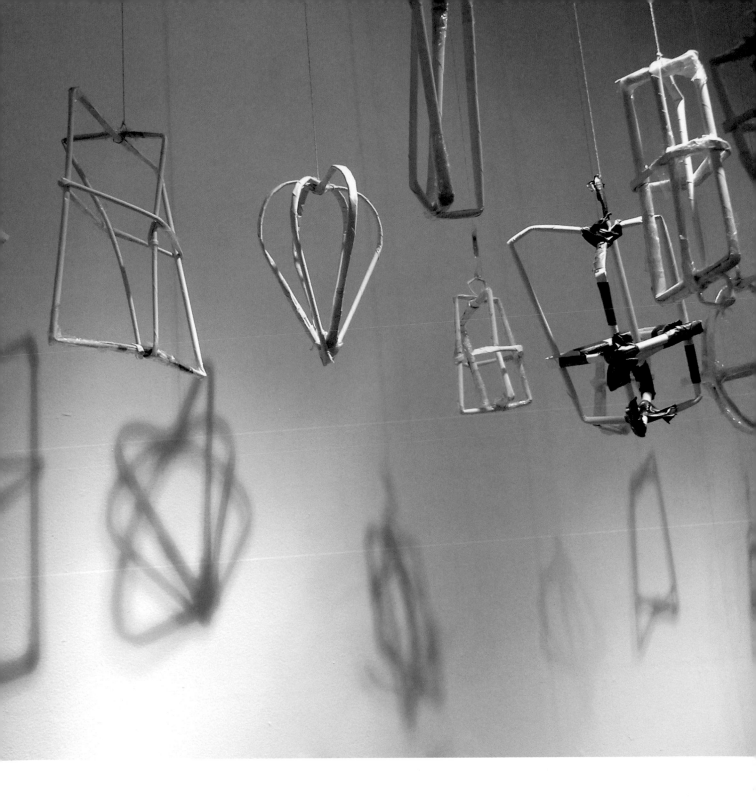

FIGURE 8 FIGURE 9 27

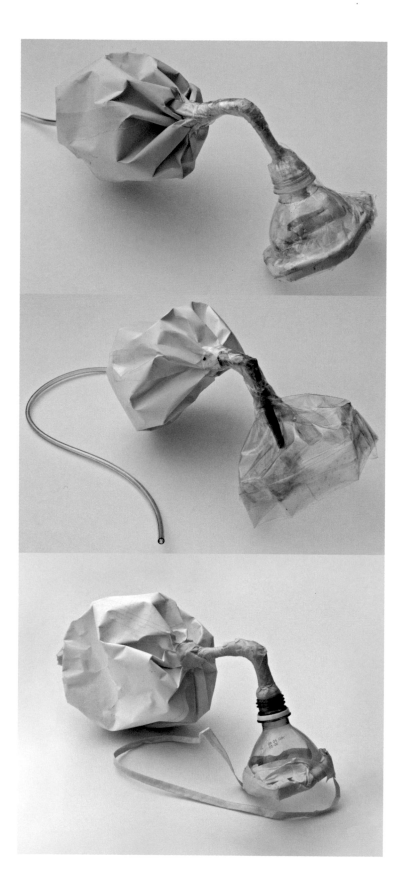

FIGURE 10

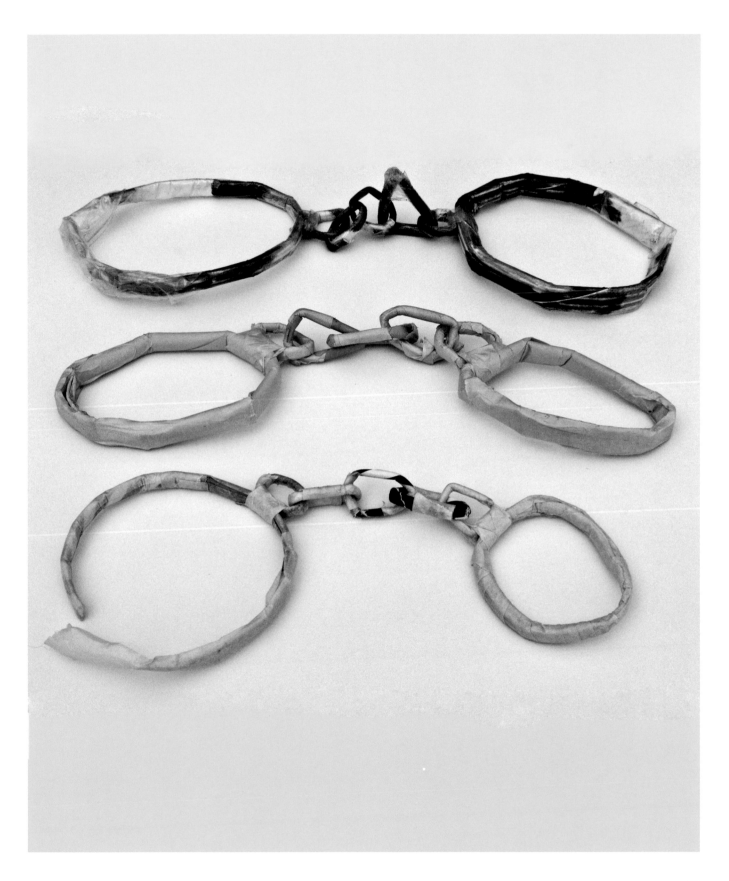

FIGURE 11 29

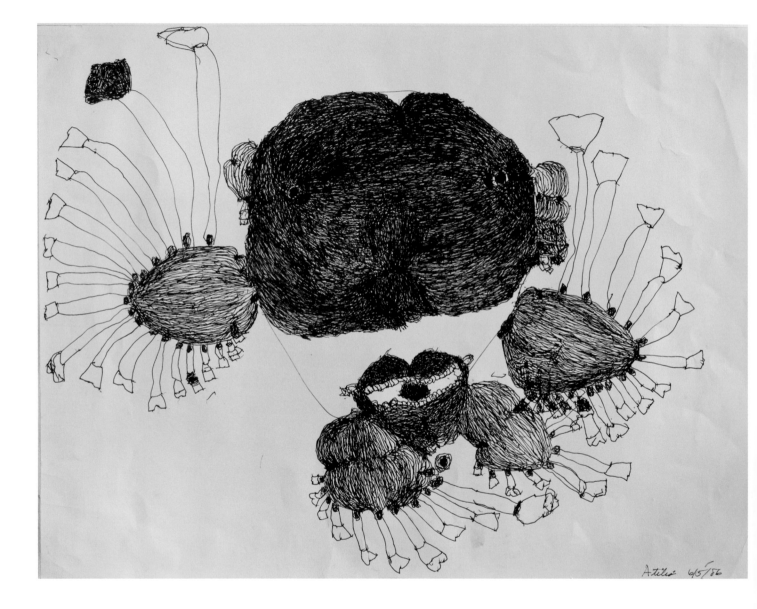

Atilio 6/5/86

Attilio Crescenti

Crescenti's drawings are scarcer than hen's teeth, as grandma used to say, for the simple reason that his active period as an artist lasted for a single year. Twenty-five years ago, at the age of sixty-one, when he was finally released from an institution and placed in a board-and-care home, Crescenti began to attend art classes at NIAD Art Center. The staff encouraged his work with pen and ink on paper, invariably images of sprawling characters with big faces and the appealing eyes and mouths of trolls. Alas, Crescenti had no sooner settled into a pattern of intense artistic production than lung cancer claimed his life in 1987.

The work Crescenti completed during this brief span continues to mystify and inspire, as much for its economy of line as for the new biology he wrought. His creatures possess the standard number of arms and legs but are inexplicably endowed with dozens of fingers and toes. No wonder their heads tilt ever so slightly with a look that is both winsome and concerned. These are cute creatures, in the expanded sense of "cute" that theorist Sianne Ngai writes about in her 2005 "The Cuteness of the Avant-Garde": the "cute object is soft, round, and deeply associated with the infantile and feminine" (*Critical Inquiry* 31, no. 4 [Summer 2005], 814). A generous, startlingly limber tenor animates Crescenti's line, as though the artist was elated by his subjects' extremely tiny teeth, or the w-i-i-i-d-e gazes that give his quasi-human apparitions the doubled awareness of the crustacean.

FIGURE 12 31

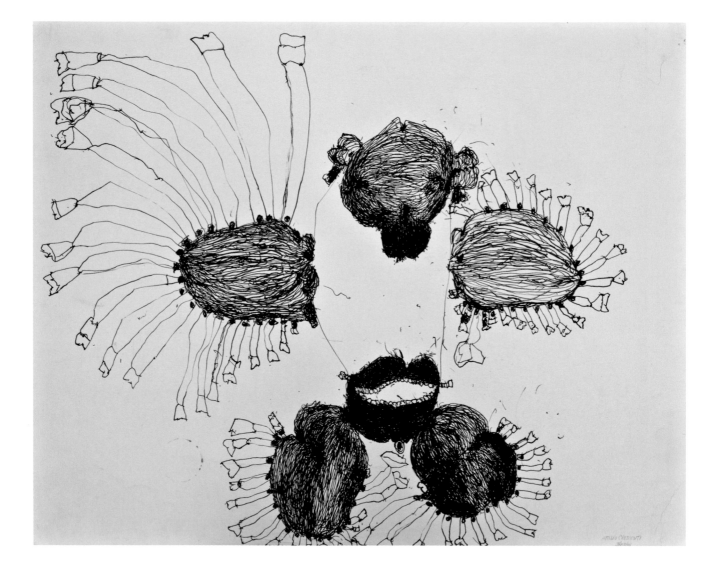

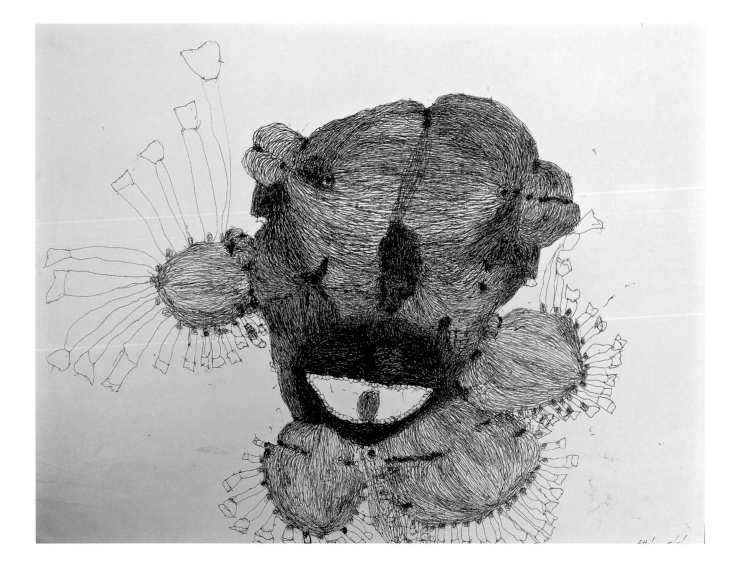

FIGURE 14 33

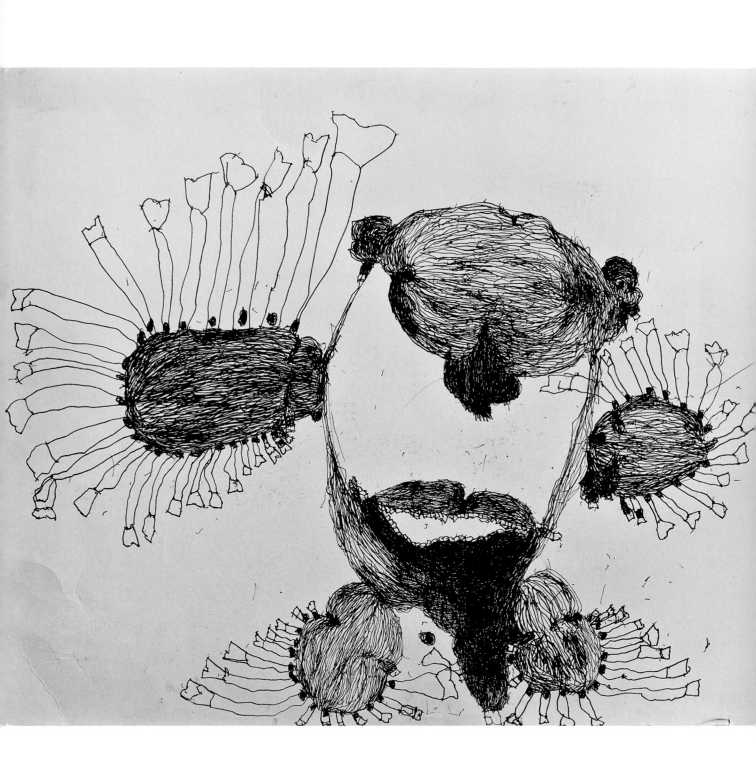

FIGURE 15 35

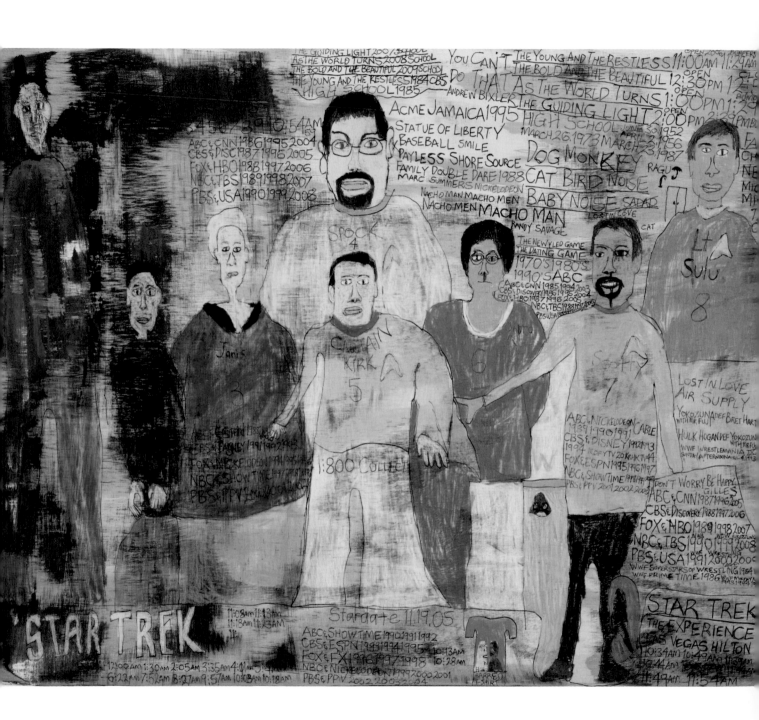

Daniel Green

Daniel Green's got what the French philosopher Jacques Derrida called "archive fever," and he locates it squarely in the anatomies of network TV (and basic cable!). Derrida's reading of Freud posits a high level of anxiety among archivists, but Green makes it go down easy. *General Hospital, Another World, One Life to Live, Santa Barbara*: dozens of daytime TV shows—along with dates, times, and place names—scroll across the surfaces of his works, forming a static backdrop to insouciant images of figures dancing, tossing pizza, or reclining in the nude. Green's *She is Naked* (2009) (fig. 17), featuring a truly modern-day Olympia, is inscribed with the birthdates of several of these TV shows as well as those of Gilles, Paul, and Eric, who happen to be staff artists at Creativity Explored. Here, everyday life and mass-media entertainment coexist in a tangled, fecund litany.

In *That's the Star Trek* (2009) (fig. 16), Spock towers over all the other members of the cast, regal in the institutional pajama-like uniforms pioneered by Gene Roddenberry's designers. Spock's beard and glasses give him an intellectual, Jeff Goldblum look that I like very much. Daniel Green's genial take on TV listings shows us what Flaubert's Bouvard and Pécuchet might have done with their indexing, had they been in a particularly good mood and something really good was coming on TV.

FIGURE 16 37

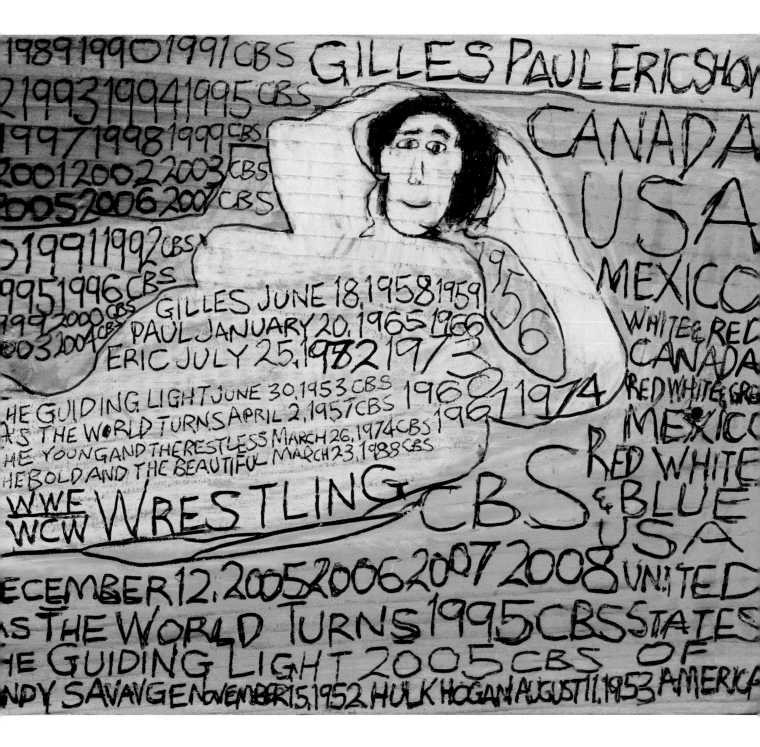

FIGURE 17 39

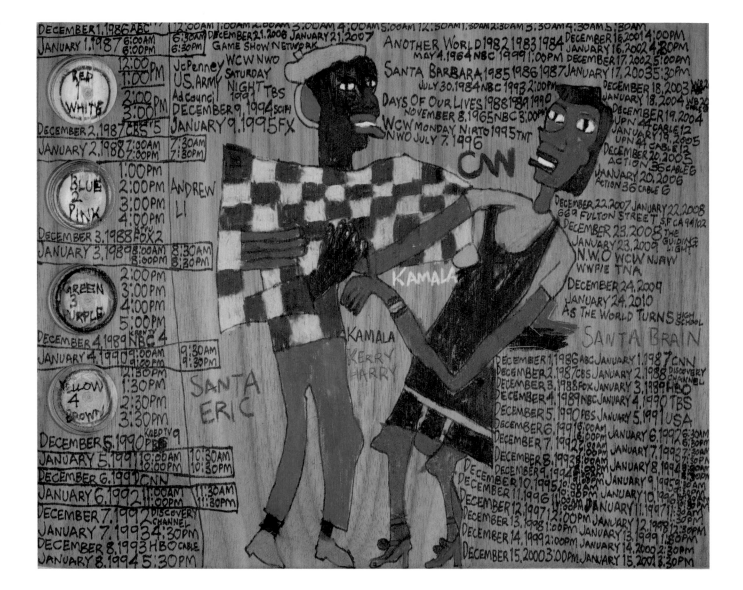

FIGURE 19 41

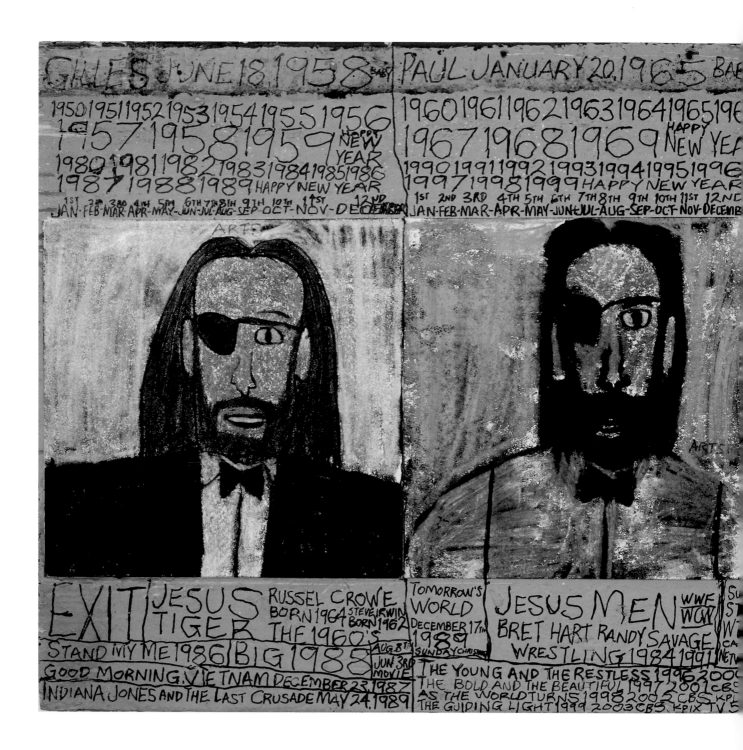

GILES JUNE 18, 1958 BABY PAUL JANUARY 20, 1965 BAB

1950 1951 1952 1953 1954 1955 1956 1960 1961 1962 1963 1964 1965 196
1957 1958 1959 HAPPY NEW YEAR 1967 1968 1969 HAPPY NEW YEA
1980 1981 1982 1983 1984 1985 1986 1990 1991 1992 1993 1994 1995 1996
1987 1988 1989 HAPPY NEW YEAR 1997 1998 1999 HAPPY NEW YEAR
1ST 2ND 3RD 4TH 5TH 6TH 7TH 8TH 9TH 10TH 11ST 12ND 1ST 2ND 3RD 4TH 5TH 6TH 7TH 8TH 9TH 10TH 11ST 12ND
JAN·FEB·MAR·APR·MAY·JUN·JUL·AUG·SEP·OCT·NOV·DECEMBER JAN·FEB·MAR·APR·MAY·JUN·JUL·AUG·SEP·OCT·NOV·DECEMB

ARTS

ARTS

EXIT JESUS RUSSEL CROWE TOMORROW'S JESUS MEN WWE SU
TIGER BORN 1964 STEVE IRWIN WORLD WCW ST
THE 1960'S BORN 1962 DECEMBER 17TH BRET HART RANDY SAVAGE W
STAND BY ME 1986 BIG 1988 AUG 8TH 1989 WRESTLING 1984 1991 CA
JUN 3RD SUNDAY CHRIS NET
GOOD MORNING VIETNAM DECEMBER 23, 1987 MOVIE THE YOUNG AND THE RESTLESS 1996 2000
INDIANA JONES AND THE LAST CRUSADE MAY 24, 1989 THE BOLD AND THE BEAUTIFUL 1997 2001 CBS
AS THE WORLD TURNS 1998 2002 CBS KPI
THE GUIDING LIGHT 1999 2003 CBS KPIX TV 5

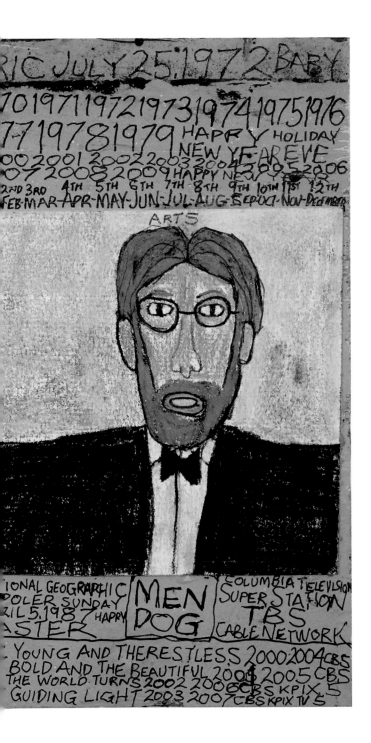

FIGURE 20 43

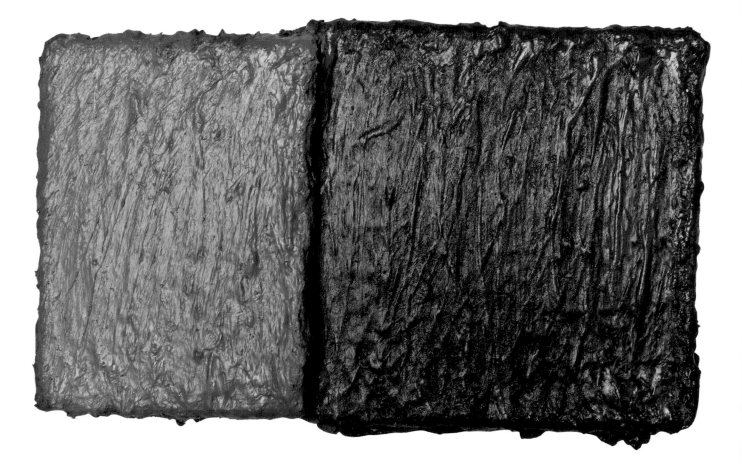

Willie Harris

Willie Harris works his paint to sculptural levels, achieving a solidity that reminds me of the impressive depth of Jay DeFeo's *The Rose*. The paint possesses its own life: it seems to have been applied convulsively, nearly in shudders. In a further nod towards the condition of sculpture, the panels are linked together, often side by side, but sometimes fitted directly atop one another to form a true bas-relief. Harris glues his disparately sized canvases together, both in simple pairs and in extended linear arrangements that recall nothing so much as the awkward line-up of an extended family photo that captures the oddities of a radically mingled genetic pool.

It is in his sense of color that Harris attains his most classic modernity. There are blues, oranges, and greens that amaze and confound with their impression of clash and contradiction, and we recall that critics of the French Fauves said that the notorious 1905 Salon d'Automne was like an "explosion in a paint factory." In some works, though, Harris sticks to more consistent and muted hues: in these there is a restraint and subtlety of color that recalls the work of the Bay Area's own John Zurier, who for several years has been an admirer of Harris's work.

FIGURE 21 45

FIGURE 22

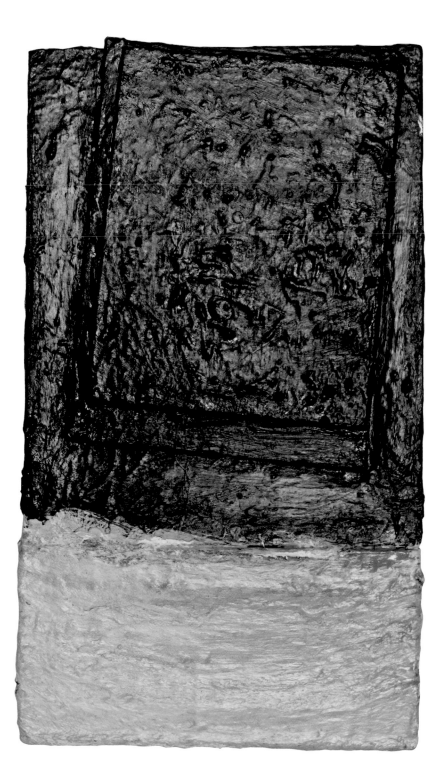

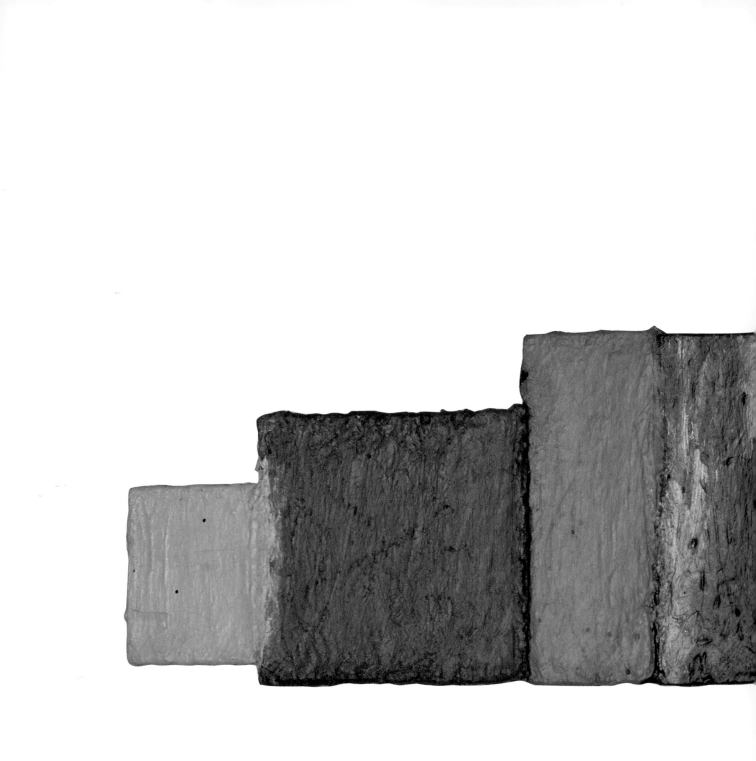

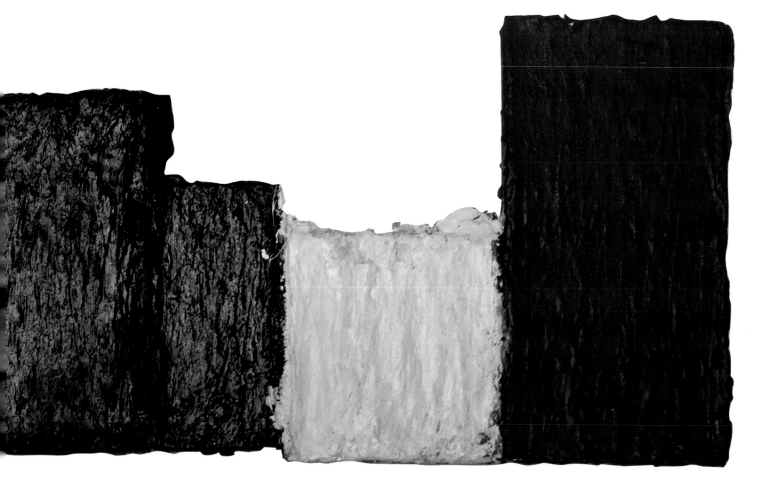

FIGURE 23 49

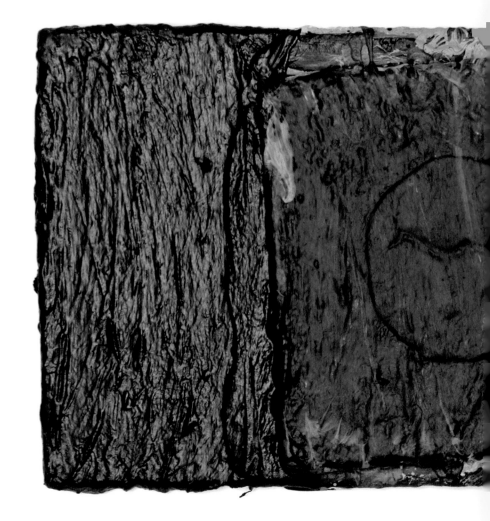

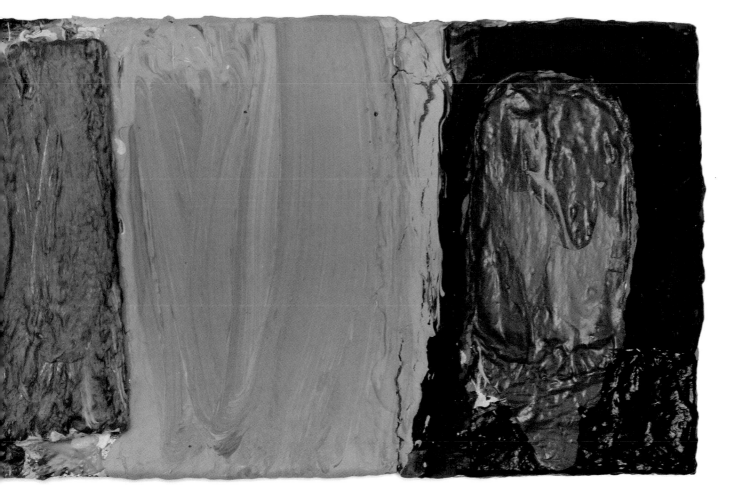

FIGURE 24 51

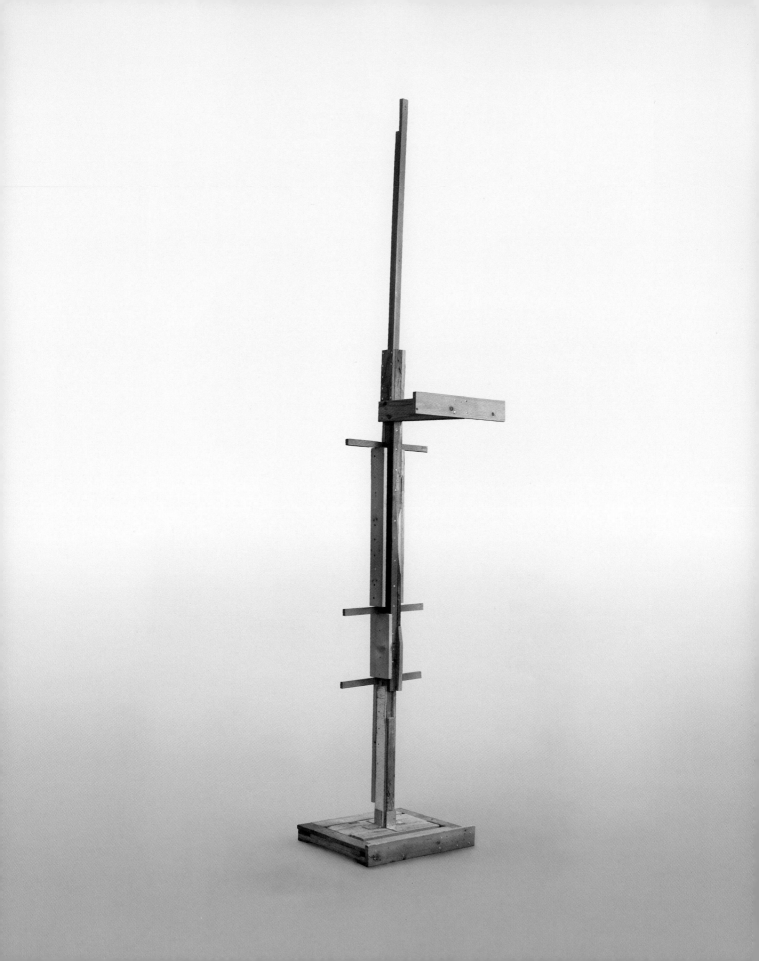

Carl Hendrickson

Carl Hendrickson constructs his sculptures with the assistance of a team of fabricators and artist colleagues. While cerebral palsy prevents him from pursuing very many projects—he communicates not in words but through emphasis of gesture and gaze—Hendrickson has produced a small, strong body of work. His medium is wood, a material with which he takes infinite pains, making certain that each piece of wood has been cut and fitted exactly as he has envisioned it. Not for Hendrickson the rare and expensive materials like teak or mahogany: any old piece from the lumberyard will suit him just fine.

Hendrickson's explorations of the way wood works are extravagant, magical, and yet paradoxically pragmatic. An untitled piece from 2009 (fig. 26), for example, investigates the perpendicular with unmatched grace and intensity, while a handwoven monochrome banner hangs from its dowel like an abstract welcome sign. Indeed, a Hendrickson sculpture is like a Platonic expression of some basic utilitarian form: a flagpole, a table, a chair. Yet a surprise element always lurks, which gives the thing back its particularity, as in Hendrickson's sculpture of a table topped with Plexiglas that reveals, and perhaps revels in, a false bottom (fig. 27).

FIGURE 25 53

54 FIGURE 26

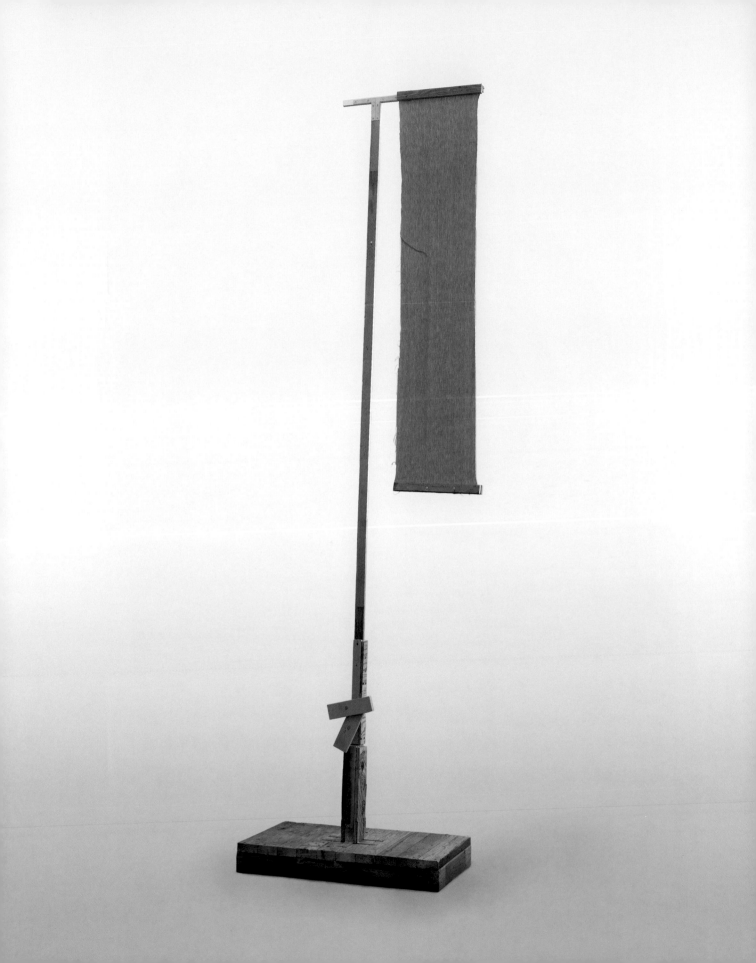

FIGURE 27

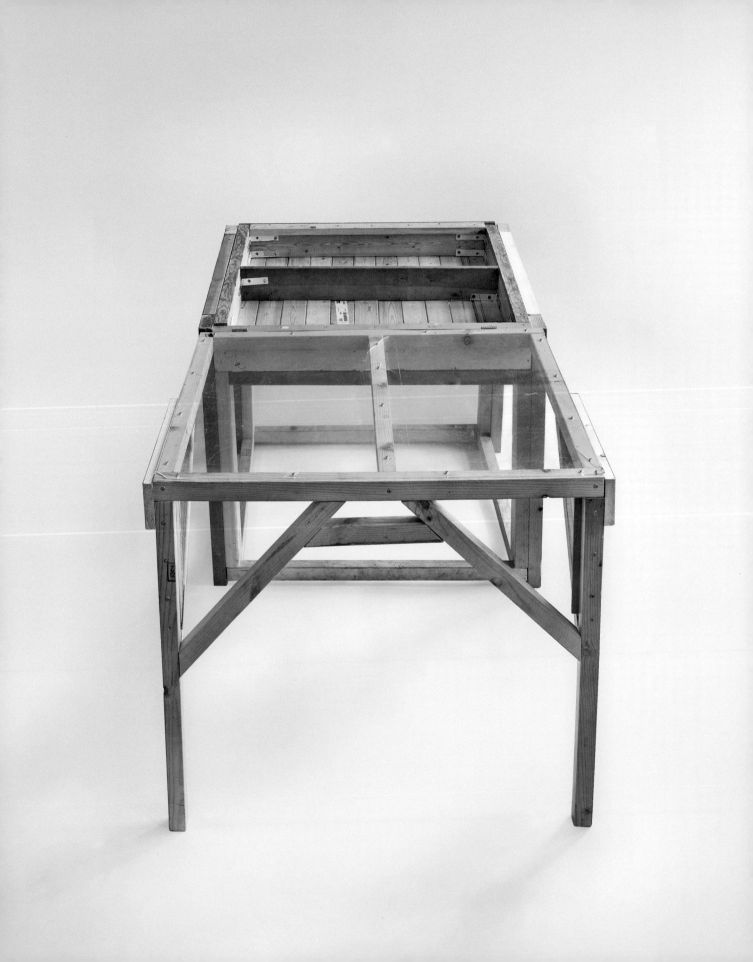

Michael Bernard Loggins

I clearly remember the opening of *Whipper Snapper Nerd* at San Francisco's Yerba Buena Center for the Arts in 1998—an exhibit of the most significant artists then at work at Creativity Explored. I looked up at the high staircase walls and saw an imposing list of troubling fears, inscribed in insistent yet childlike script. Had some analyst created this worrisome taxonomy? Then I met Michael Bernard Loggins, his tall dark hat first, a nametag pinned to it in a daring fashion statement: peering from under the hat's wool brim was a shiny inquiring face that looked to me to be frightened of absolutely nothing. How could this brave and creative soul have authored the text on the wall behind him, so emblazoned with fear? "Fears of Your Life" was one of the most arresting and complete list-poems I'd ever encountered (fig. 28).

As I read on I noted fears I'd never had myself, yet in the months that followed I began to develop them, like tics. But Loggins has more than one string to his bow, and he is not only an expert on fear: his writings "On Love" are equally expansive, imaginative, infectious.

Loggins's enthusiasm and energy for writing, drawing, and publishing gave the zine—that staple of mid 1990s post-punk culture—a new lease on life. Like the Scottish artist Donald Urquhart, Loggins combines words and pictures with élan, a fresh, vivid, and ultimately mnemonic take on the world: this is work designed to remember for us, and to prod us into memory.

1. Fear of Hospitals and Needles.
2. Fear of school and Dentists.
3. Fear of Black cats.
4. Fear of Monsters being under my bed. Fear of intruders coming into the house to steal things and hurt us all.
5. Fear of going to Jail as Being Punish. For doing something very wrong and have to stay in For a long Time.
6. Fear of being Followed.
7. Fear of Dogs.
8. Fear of strangers.
9. Fear of Time Bombs.

10. Fear of Deep waters.

11. Fear of Noises and bumps in the middle of the Night.

12. Fear of being chase by bulls.

13. Fear of being Lost.

14. Fear of Elevators.

15. Fear of Doors when they slams.

16. Fear of Fires and smokes.

17. Fear of Guns and Knives.

18. Fear of Authority and Punishment.

19. Fear of Toys that comes on by itself without anyone touching it.

20. Fear of Someone doing Wrong to you and don't want you to do Wrong back To them.

21. Fear of Spiders and Roaches. and mouse raccoons and Rats too.

22. Fear of getting in deep trouble. or going to get in deep trouble.

23. Fear of being caught with another woman after cheating on your wife.

24. Fear of getting run over by a car when not Paying Attention.

25. Fear of being caught by being with the Person that steals.

26. Fear of Bees.

27. Fear of getting left alone.

28. Fear of going to the Doctor.

29. Fear of Riding in deserted Area's when it's dark.

30. Fear of your life being in great Danger and Threaten.

31. Theres Los Angeles Fears.

32. OAKland Fears.

33. San Francisco Fears.

34. Fear of Torados and thunders, and lightning too.

35. Fear of being in wrong Places at the wrong time.

36. Fear of dropping your soda as it hit the ground and Fiz on You,

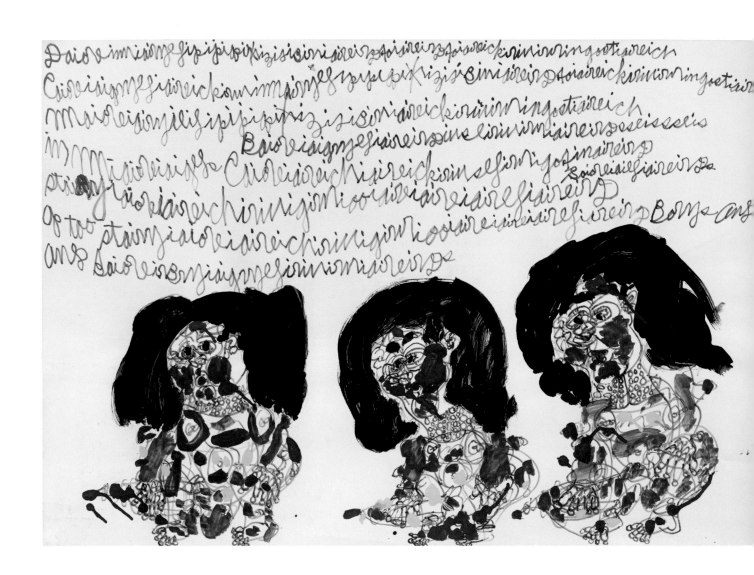

Dwight Mackintosh

Dwight Mackintosh started making art only in old age. Over seventy when he first came to Creative Growth Art Center in Oakland, right away he took to art as though he'd been doing it all his life. He had survived sixty years of a grim, hard-knock life in a horrific Dotheboys Hall sort of institution, yet he had come out of it with his creative spirit intact. Even Mackintosh's subsequent strokes didn't slow him down, but rather catapulted him into a broader range of creation; initially he drew only boys—whom he called "boysses"—but his subjects eventually encompassed angels, cars, trucks, engines, carriages of many kinds, and girls.

Mackintosh's view of anatomy is an instructive one, as his peculiar drawing technique allows the viewer to see straight through bodies and heads like some kind of gestural X-ray. It is thought that most of his imagery is autobiographically derived, so the rows of boys, many sporting sturdy erections, suggest the libidinous realities of adolescent life in an institution.

Like those of other artists in this exhibition, such as Bertha Otoya and John Patrick McKenzie, Mackintosh's drawings incorporate extended lines of text that form a backdrop, or mise-en-scène. Mackintosh's texts are distinctive, however, in that, while ostensibly nonsensical, the precise order of his letters has never varied.

FIGURE 29 67

FIGURE 30

Dwight MacIntosh 12-17-80

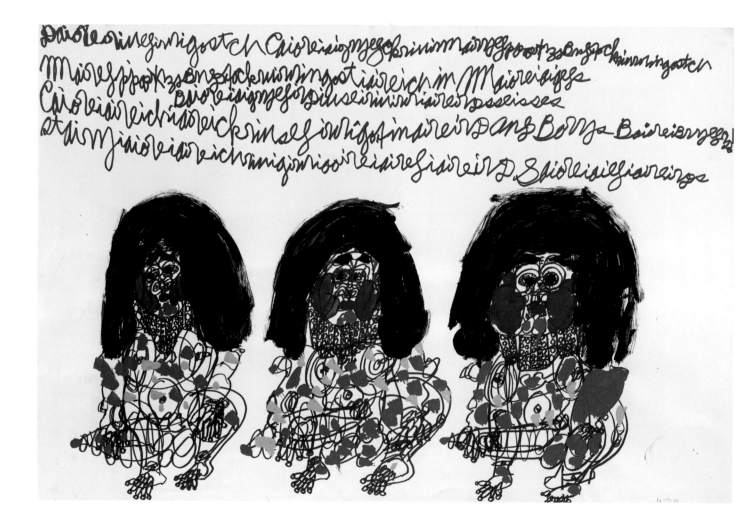

FIGURE 31

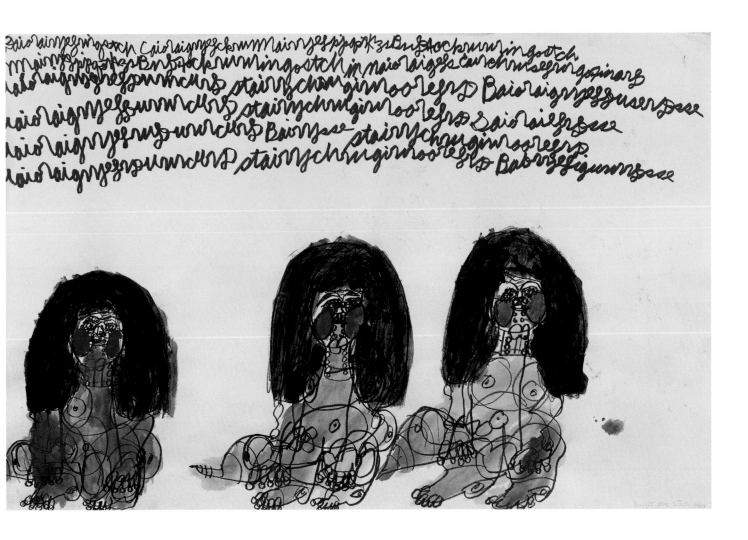

FIGURE 32 71

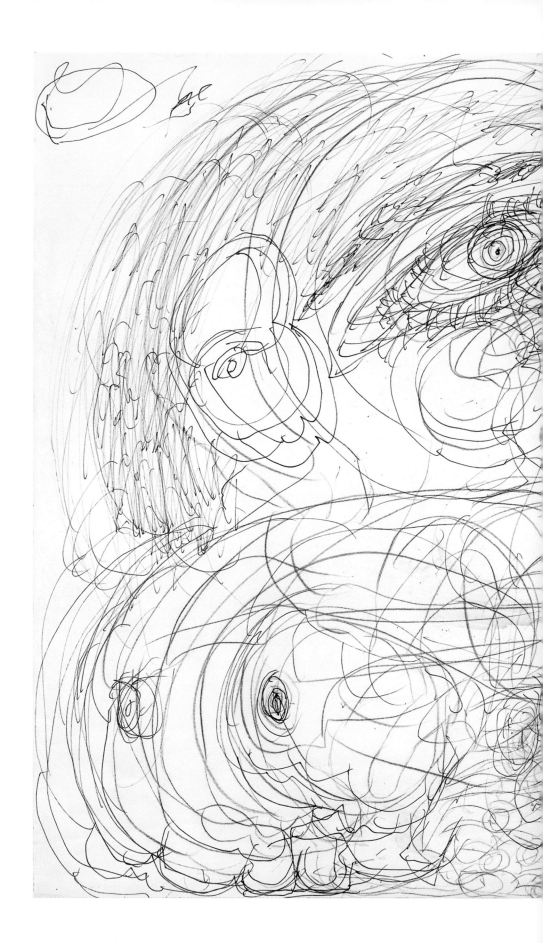

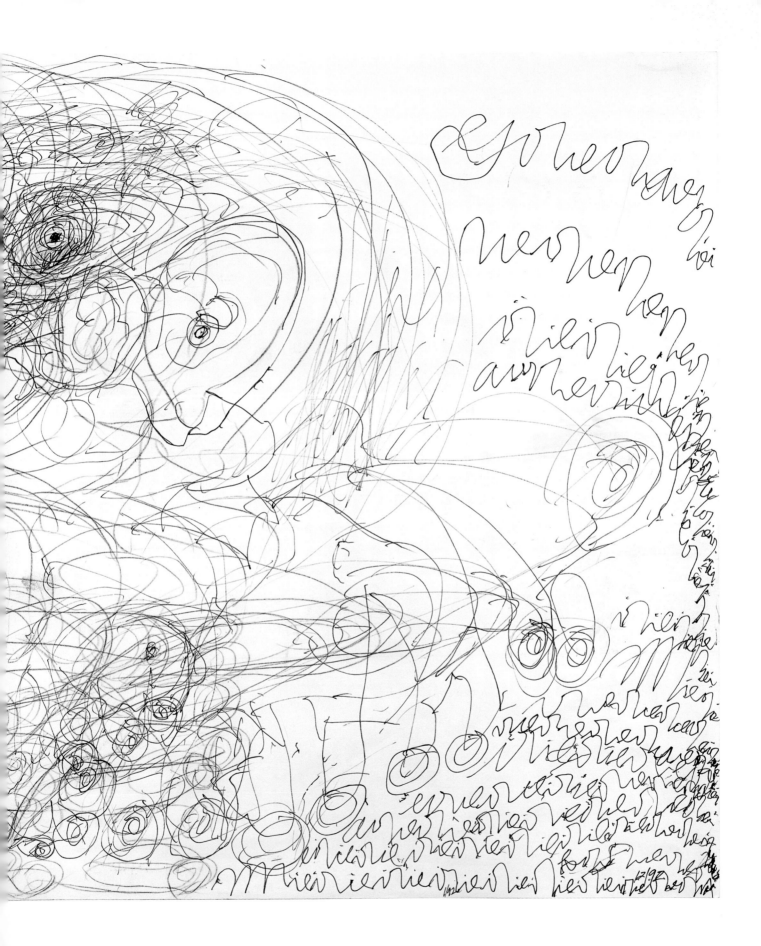

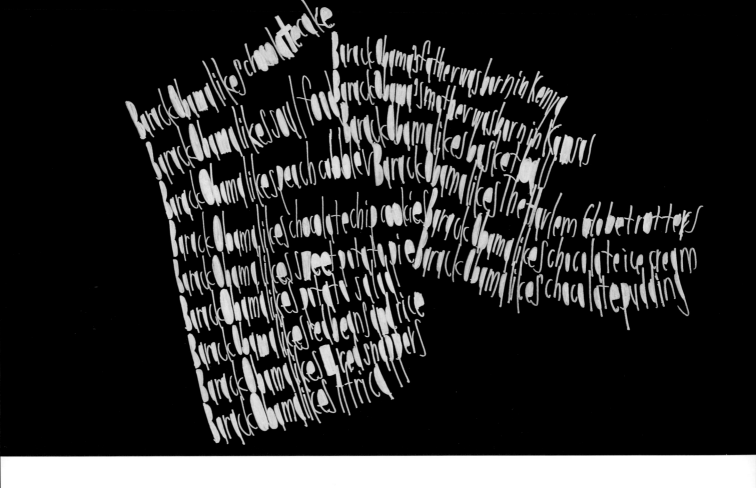

John Patrick McKenzie

The rounded letters of the alphabet, those that include circles, the o's, the d's, the e's, the p's and q's, ah, you know them all—these are the targets of McKenzie's delight. His distinctive script is based on filling—like a meringue-filled *schaumrolle*, his vowels and consonants bulge with something extra.

In the field of poetry, a group of New York–based poets have worked collectively for the past decade on a movement called "Flarf," in which received ideas of creativity and originality are tweaked through various Google-based procedures. Like the Flarf poets, McKenzie may start out a poem/picture by positing his, or someone else's, name, plus "is" or "likes," and assembling as many varieties of that sentence as he needs to make the picture work: "Barack Obama likes chocolate cake. Barack Obama likes soul food. Barack Obama likes peach cobbler. Barack Obama likes chocolate chip cookies." It's an interesting amalgam of the conceptual and the lyric. "Barack Obama likes red snappers" (fig. 34).

The Dada tone of McKenzie's seemingly limitless and rather random characterizations is at times combined with found images that give pictorial dimension to these clouds of signifiers, as in one work that is drawn on a Felix Gonzales-Torres poster depicting the sky and a solitary bird (fig. 39, frontispiece). Other works, such as an untitled piece from 2007 (fig. 36), derive from lists of similar-length words arrayed either linearly or in an acrostic fashion to create loosely entwined threads of meaning that are as poetic as they are visually compelling.

FIGURE 34 75

FIGURE 35

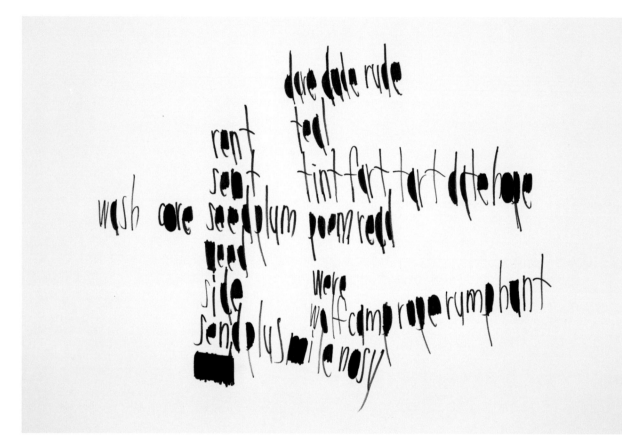

FIGURE 36 FIGURE 37

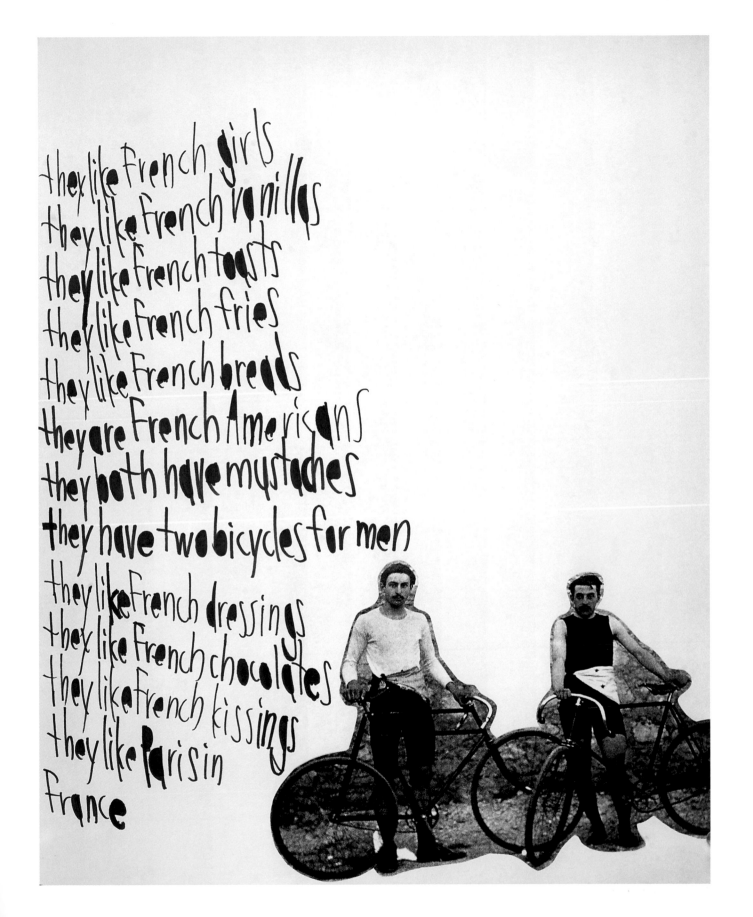

they like french girls
they like french vanillas
they like french toasts
they like french fries
they like french breads
they are french Americans
they both have mustaches
they have two bicycles for men
they like french dressings
they like french chocolates
they like french kissings
they like Paris in
France

FIGURE 38

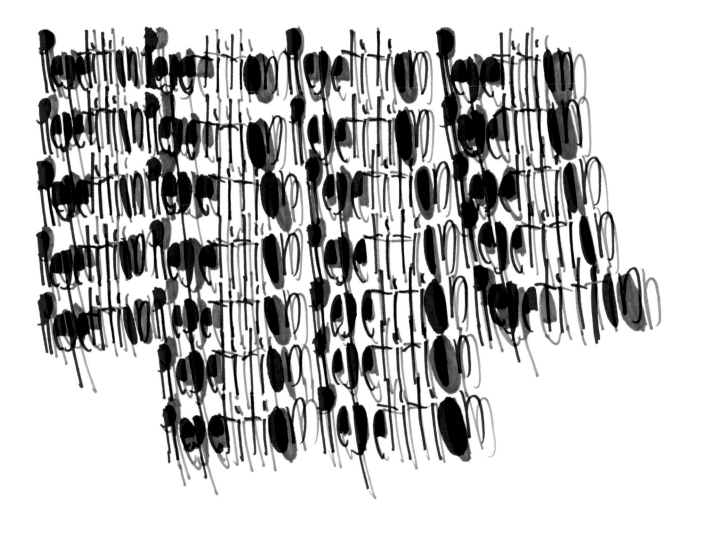

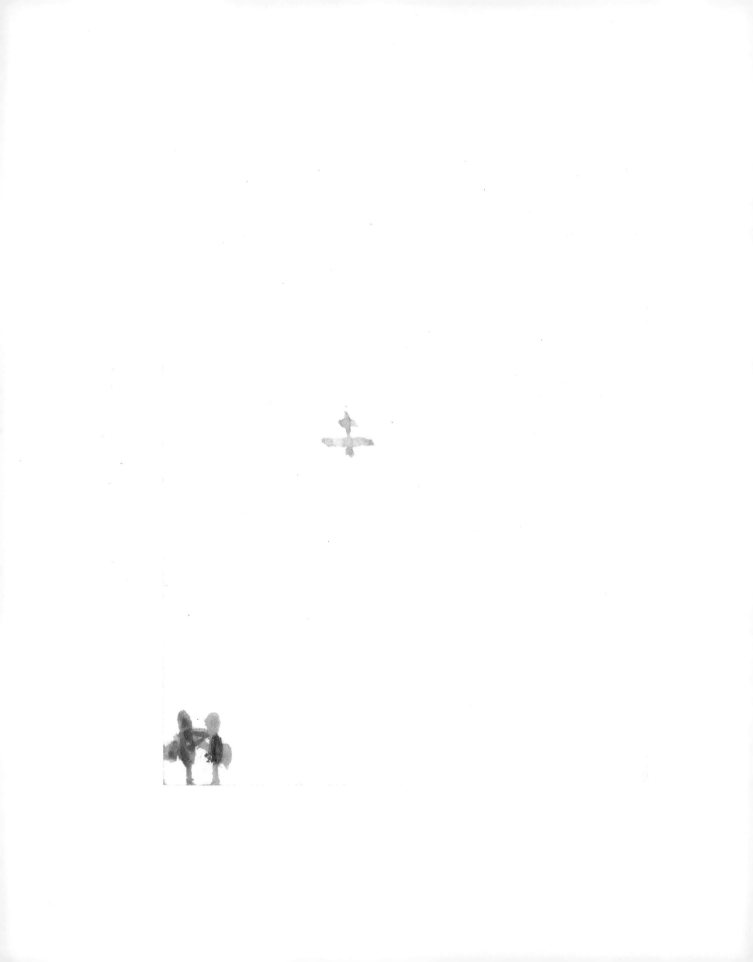

James Miles

James Miles's finest work manifests itself in gestures of extraordinary delicacy and ease. A taco truck discretely placed at the very bottom edge of the composition, a pair of tiger cubs wrestling in the infinity of an unmarked ground, a tiny band playing on a vast, broad stage . . . Miles's vernacular images are often deployed in spaces that possess the scale but never the terror of the sublime. On the contrary, Miles's space is accommodating, supportive, and connecting. In his drawings we may see two images yoked together by the whiteness of the blank paper space—disparate images that we might never have thought of uniting, but whose association brings us closer to an expanded definition of the real. In *Men and Plane* (2006) (fig. 40), for example, two tiny human figures stand beneath a plane's vertical progress earthward from the far heaven of the sky. Our eye is pulled from one image to the other until it alights on the space in between as the quiet focus of the work. Miles uses form to implicate the edges of nature, like the symbolic tropes of the Japanese haiku, which express the subtlest ripples of being and time.

The small scale of Miles's drawings contrasts with their suggested capaciousness. This is true in his simple sketches as well as in his more complex compositions, such as an untitled piece from c. 1999 (fig. 41), in which the artist appears to render multiple perspectives (indoors and outdoors)—and perhaps various moments in time—in a single picture.

FIGURE 40 83

FIGURE 41

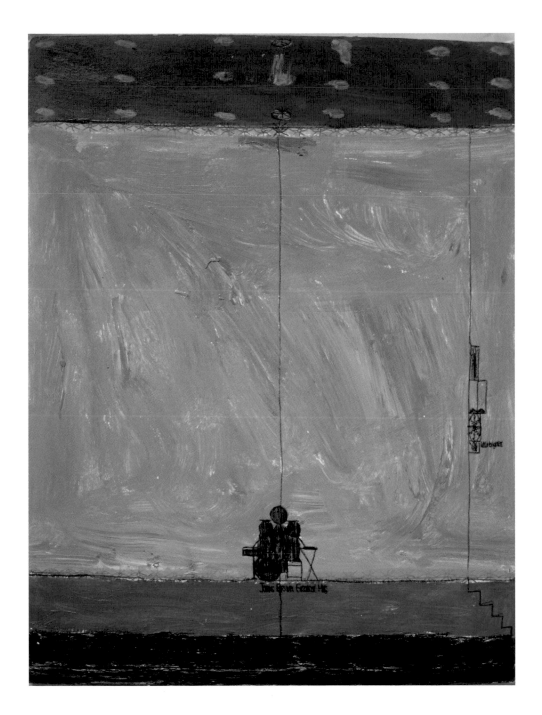

FIGURE 42 85

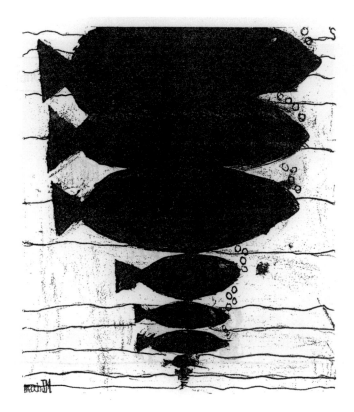

FIGURE 43

FIGURE 44 87

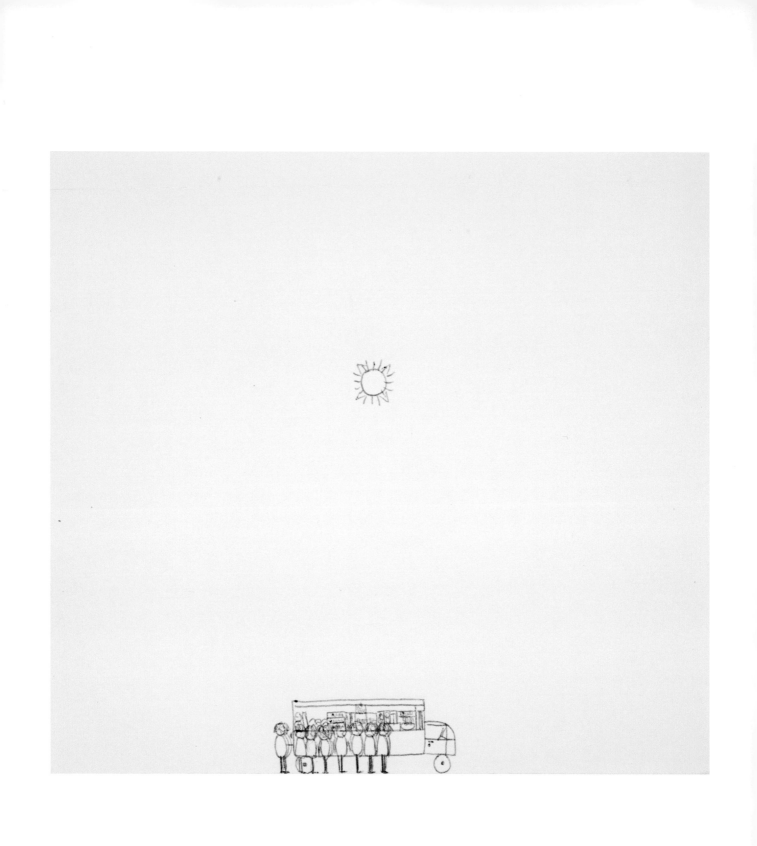

FIGURE 45

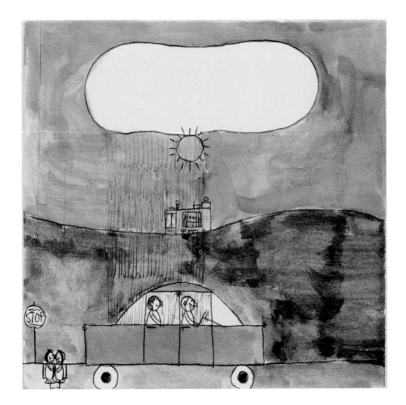

FIGURE 46 89

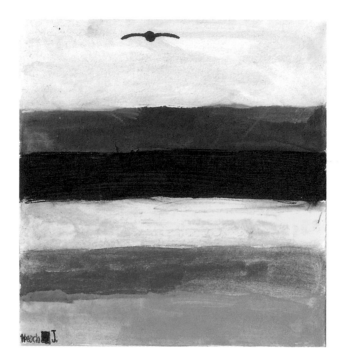

FIGURE 48 91

Dan Miller

Matthew Higgs has written cogently about Dan Miller:

> Diagnosed with autism, and with few conventional verbal communication skills, Miller has developed an intensive body of work that employs language as its fundamental subject and departure-point. His extraordinary drawings . . . take the form of accumulations of descriptive texts, alphabets, and numerical sequences. (The texts often have strong biographical references, e.g. acknowledging specific Bay Area locales, and aspects of his immediate day-to-day life and family history.) Typically superimposed on top of one another, these individual words, numbers, and phrases start to merge, creating all-over fields of partially obscured and often illegible texts (whitecolumns.org).

The visceral quality of Miller's drawings has been much remarked upon; the energetic nature of his repeated gestures generates a dramatic tensile power. While so much energy may seem difficult to control—always on the verge of explosion or collapse—Miller deftly keeps disaster at bay. He always leaves some white space open to breathe like a safety valve.

In the Spanish documentary about Creative Growth artists, *¿Qué tienes debajo del sombrero?* (Lola Barrera and Iñaki Peñafiel, 2006), Dan Miller is the sweet, cute one in the background, scurrying like a dormouse in the wake of Judith Scott's assured and acquisitive Red Queen. But on paper he lets it all out, and his best work achieves a clattering poetry of infinite discrimination. Concentration often seems to go hand-in-hand with certain forms of disability, and Miller concentrates on building oneiric forms into spaces of genuine rue and foreboding.

FIGURE 49 93

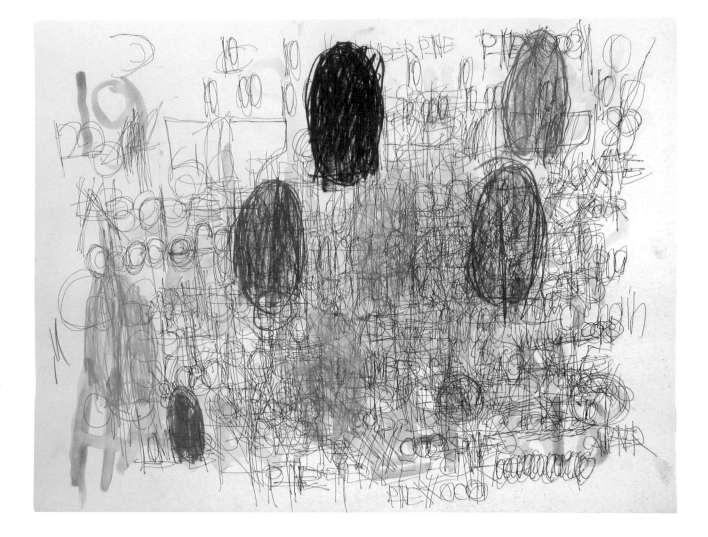

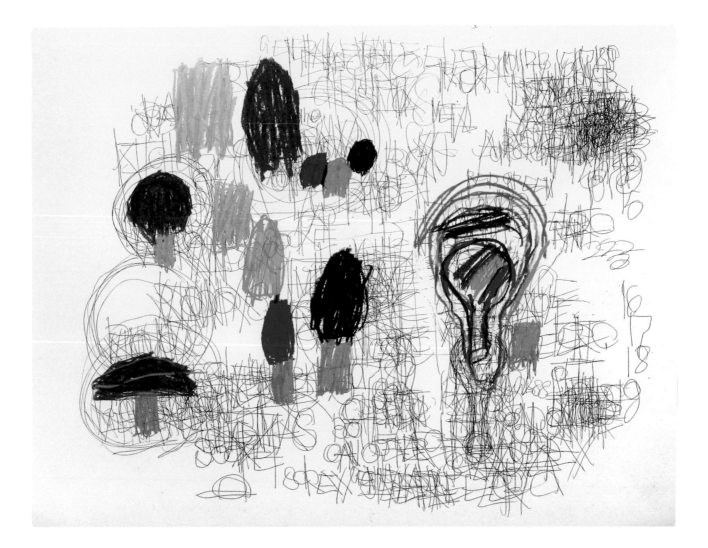

FIGURE 51 95

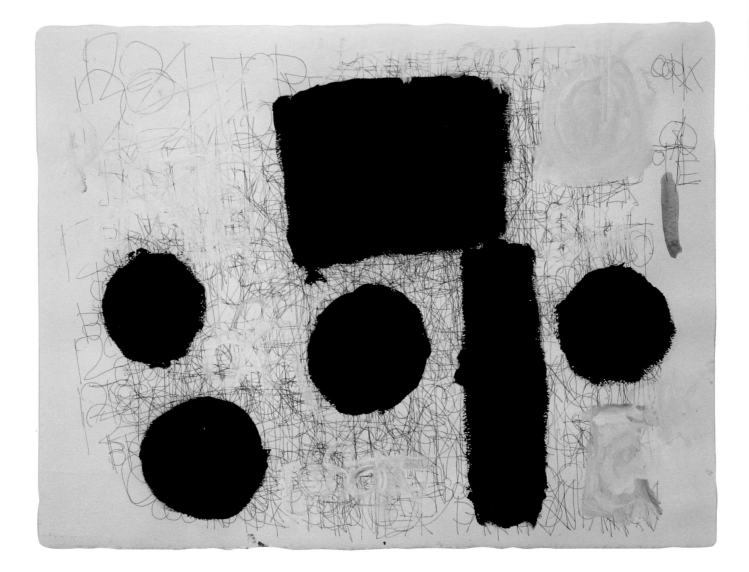

FIGURE 52

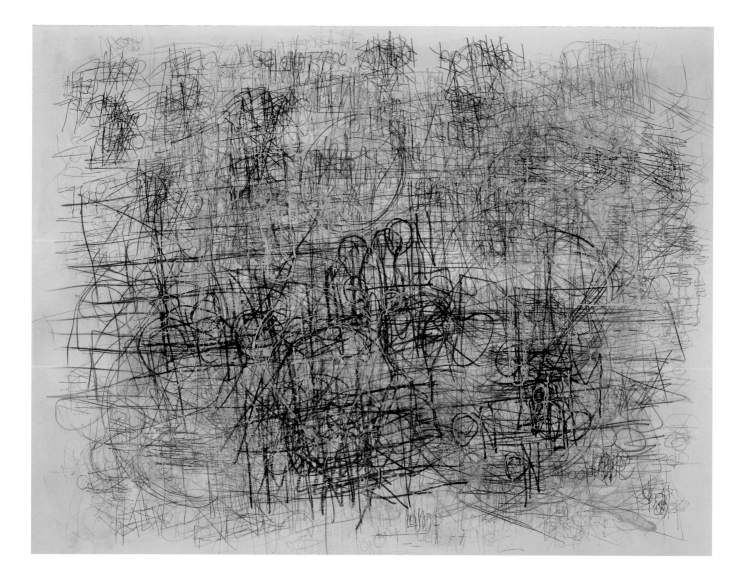

FIGURE 53 97

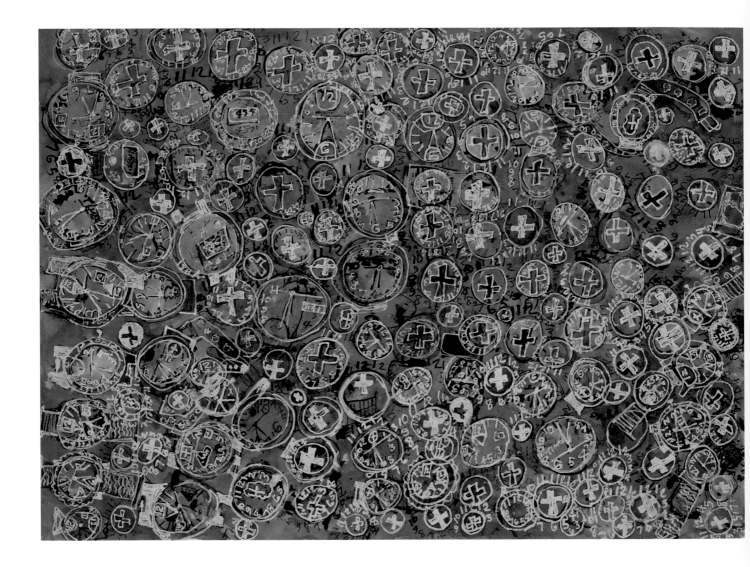

James Montgomery

James Montgomery's dramatic all-over renderings of clocks and wristwatches (and the occasional boom box) throb and pulse with authentically Surrealist energy. His manic arrays of watches, marked by crosses encircled in gray, propose a new account of their evolution: were watches and clocks once crosses that grew into mechanized bearers of measure? Or are these crosses allusions to the Swiss propensity for timekeeping? In any case, Montgomery's crosses and timepieces coexist delicately: numbers appear around the rim of the frame, tentatively, as one who might excuse himself with a mild "Pardon me." There has always been something mystical about the clock's precise twelve hours, and how we have come to naturalize these most abstract of machines.

Watches on Orange (2007) and *Watches with Leaves* (2007) (figs. 54, 55) are shaded in autumnal tones while in two works from 2007 (figs. 56, 57) misty greens and pinks pulse between the clock faces like sunlight settling on a forest glade. Here the clocks don the cheery insouciance of Easter eggs hiding on the White House lawn. In this spring-like haze, clocks and their faces feel like birth and promise—ornamental and yet organic—Montgomery buoyed with a bit of Lalique.

Finally, the twelve photograms mounted in a grid (fig. 58) display Montgomery's fine sense of shape and placement within an economy of white and gray and black, as precise and quirky as bicycle parts.

FIGURE 54 99

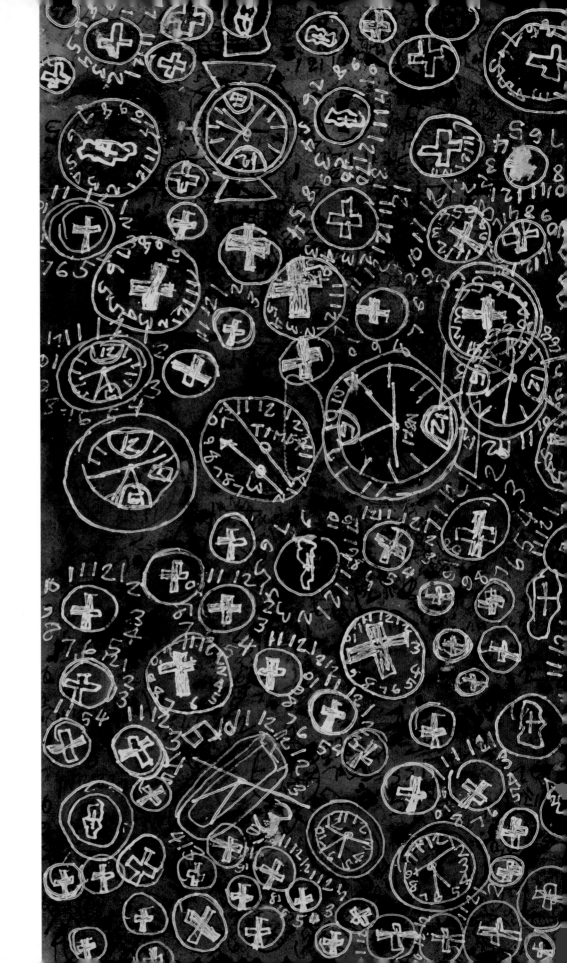

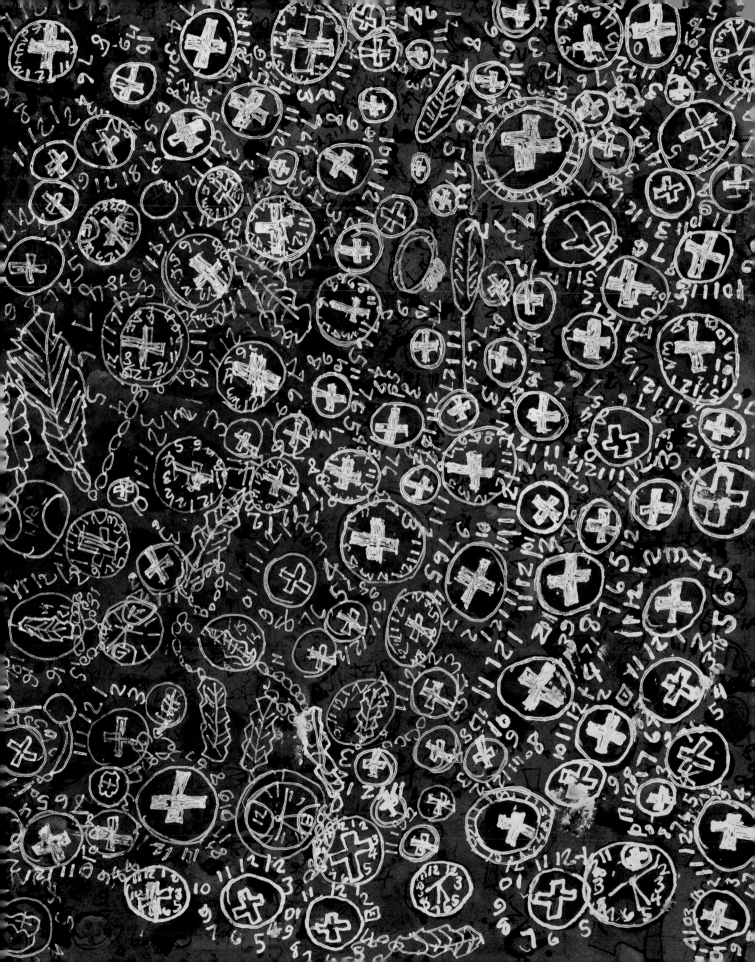

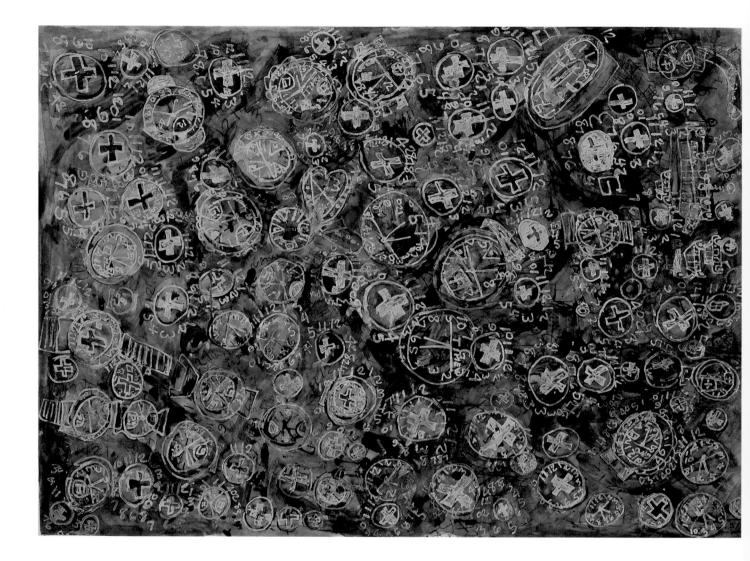

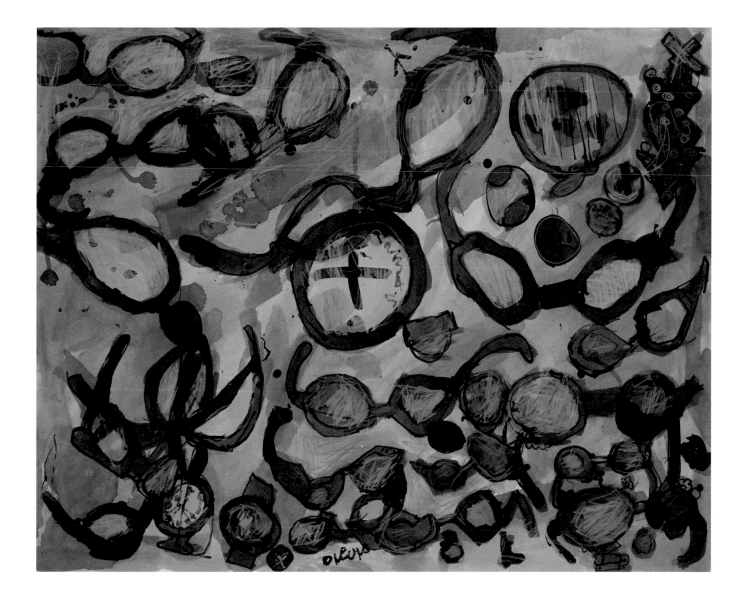

FIGURE 57 103

FIGURE 58

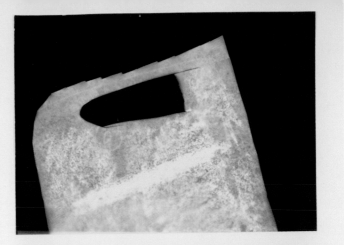

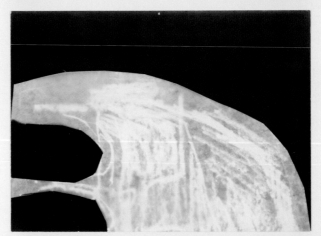

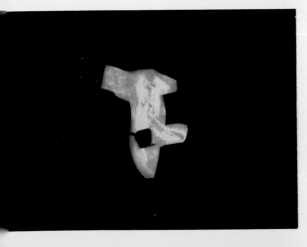

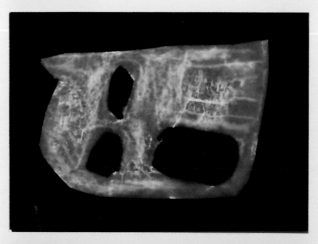

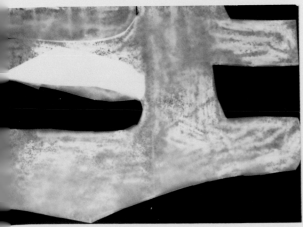

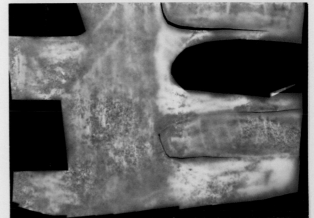

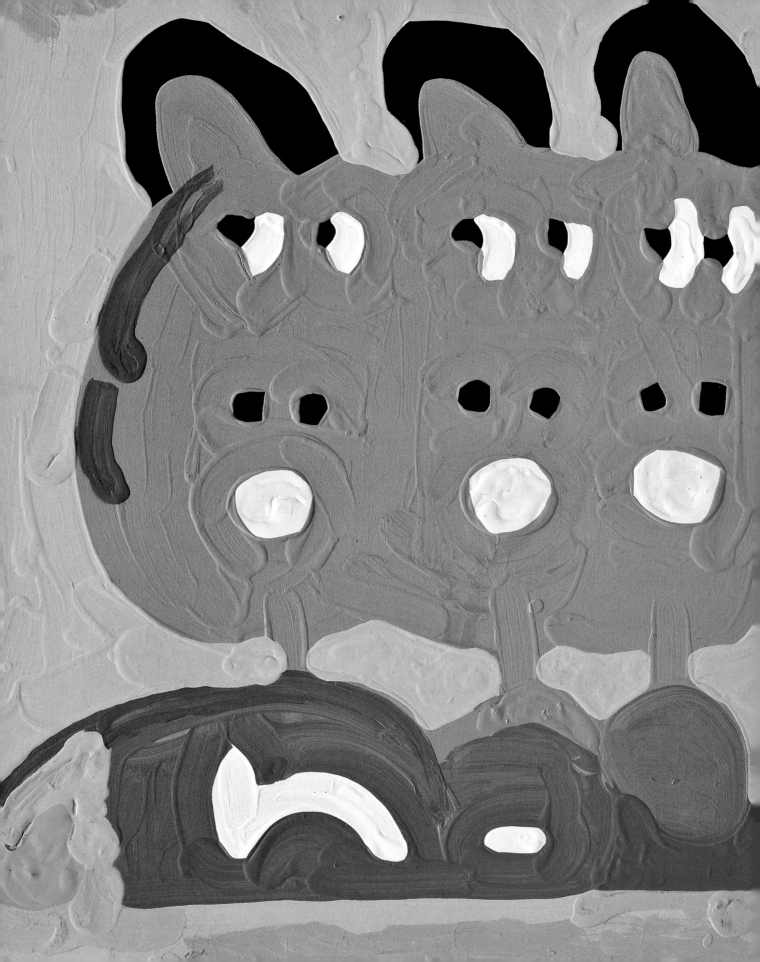

Marlon Mullen

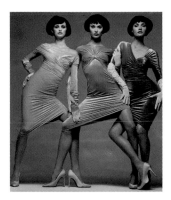

At first glance, we might think of Marlon Mullen as a latter-day Matisse, with his Fauve colors and lyrical, vaguely Orientalist forms. Yet his method indicates a wholly different character: Mullen's paintings are all derived from photographs found in newspapers and magazines. Most of these source images are lost, but NIAD Art Center, where he works, has preserved one or two. How extraordinary to see him translate a *Dreamgirls*-style photo of three saucy models (at left) sporting high fashion shoes into Untitled (2005–2006) (fig. 59), in which he has made knobs of their bobbed hair cuts, fused their nearly identical faces, and given only the faintest nod to the fashion itself: a darker shade of orange and a patch of purple for the dresses and just a dollop of blue for one of the elbow-length gloves.

Marlon Mullen has his cake and eats it too, for his best work gives back to the viewer fragments of a perceptible world, while rejoicing in the anarchic freedom of abstraction—a love of color and gesture for its own sake. Out of an intensely mediated advertisement comes a figure of joy, even awe—and so splendidly done, look at the darker brushstrokes giving shape and depth to the general wash of pumpkin. It is work whose rhetoric is perfectly attuned to our time, an abstracting time in which outline trumps the inner, when we're all straining to see or find the bigger picture.

FIGURE 59 107

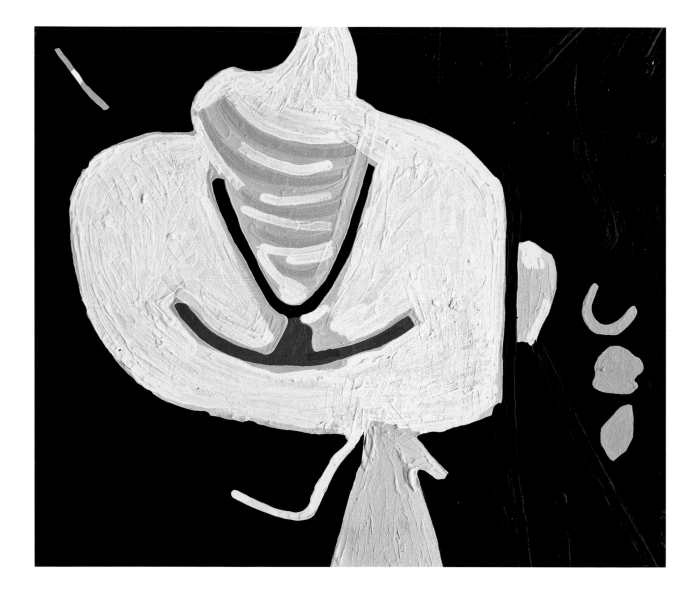

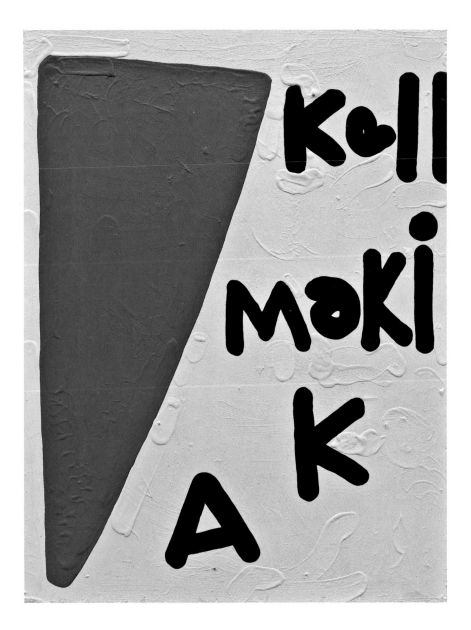

FIGURE 61 109

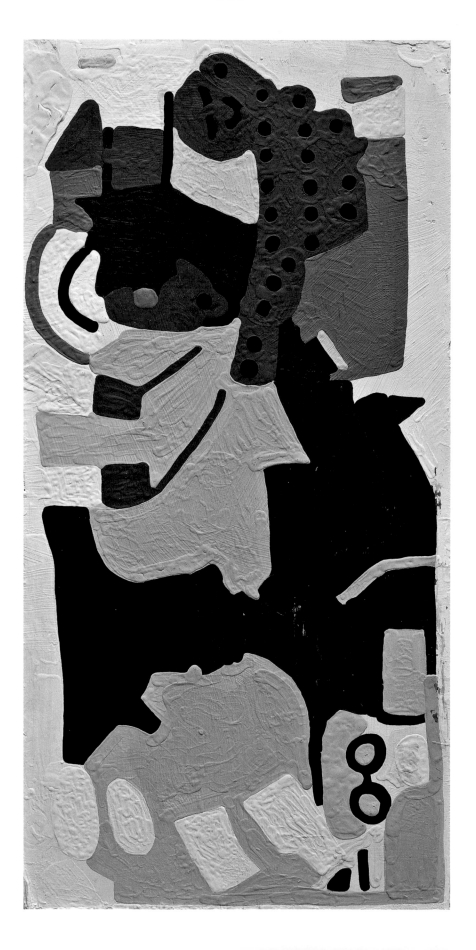

FIGURE 62, A–B

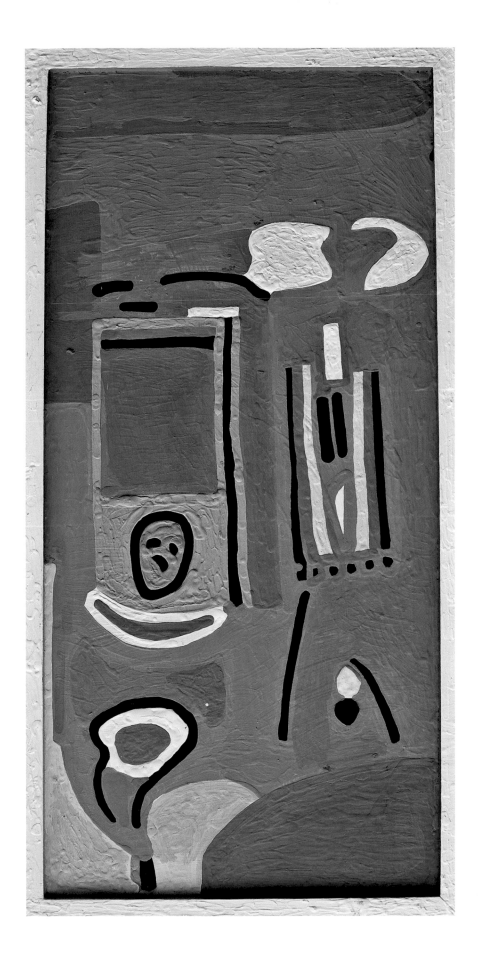

FIGURE 63

Bertha Otoya

Bertha Otoya's cryptic creatures—fish, amphibians, and serpents—multiply and grow to outsized proportions like an evolutionary odyssey run amok. Perhaps she was attracted to the project of taming menace, of recognizing and exalting the innate goodness of even the most traditionally menacing of God's figures—yes, even the monstrous.

Otoya's native language is Spanish and even in that tongue her capacity is limited, yet her prints incorporate handwritten transcriptions from various texts, many of them academic discussions of cognition and the brain. Indeed, language initiates her drawing process as she inscribes row upon row of text to create a horizontal framework akin to the plain five-line staff of modern music notation. But instead of F-sharps or D-flats, silent creatures float in a dreamlike trance, mouths open, across the bars toward an unknown destination. In Otoya's work the phantasmagoric attains the devout condition of music.

FIGURE 64 115

The angel vanished. The grow-ups both mother and fa. A her and aunts—
as the years passed, she doubted if she had really seen it. Hallucination or reality. though
his intellectual spirit that we grew up a lawyer, brilliant, warm witty, intellectual, he loved. t
had died in that bedroom. But his favorite little room, she said was the tiny dressing room.
each had their visios, as did Emanuel swedenborg, the great eighteenth century chemist and mys
right up to the twenti beginning the immortals who have their homes on
and mills out me, that wonderful man spent six hour trail
tination to thank him, but either I misplaced the add
from the moment we began to talk on another level we c
never once do baby angels playing up and down a staircase! It was the stairw to the house when we think about dying. we
and give thanks unceasingly, so that blessings shall contin
form as to appear inconsequential. Easily ignored. Remember that I was the descendant t
charismatic preachers, all of which we lumped together with yet how to explain these fl
up or your hand reaches out before the instrument rings, knowing he or she is about to call I ha
climbing the rollers and swimming down the swells. He headed for Hawaii in the directio
part way to long Island they lay becalmed they rocked on a quiet sea waiting. Had they had the spanne
with some friends and with a pack on her back had gon first to Israel and then to Greece they la
mama in a village on a hill their rooms had a terrace with a slate floor overlooking the harb
drinking coffee.
Explore their garden in the first spinning place onto the fields of prais, and after the
they went on a little farther and built the altar and lit the fire and Abraham s
In the history books of the old testament, the only angel mentioned is the angel of Death. It des
$85,000. In the camp of the assyrias. that army being ranged against the Jews. this was such a
With a wonderous use of pronouns. sennacherib, king of assyria was invading. Judah. H is ar
the touched the lips of the holy prophet with this coal, saying your sin is purged. the angel Raphael
Bar had died, and his grandson, Belshazzar, (who remember, saw the handwriting on the wall and
God, to interpret is for him—Belshazzar had lost his em pire, conquered by cyrus His successor, Darius, w
il. having survived four oriental potentates was by now one of three great presidents, ruling imm
ages toward God. He walks therefore with staff and san dals water found and wallet held a ster
rather that mysteries are presented to
turb: for this is the ru
instead a

...t hat. she. was. overtired. and. ex. cited. that the

not. forget. it. my. father. on. the. other. hand. saw. nothing

put. in. the. magnificent. paneling. in. the. bedroom. or. glass

main. bedroom. the. those. on. the. spiritual. path. But. Dante

the. German. philosophic. genius. Rudolf. Steiner. if. you. want

s. created. the. golden. generation. of. mortal. people. these. lived

imagine!). six. hours. of. his. time. to. ensure. that. I. limped

u. had. left. by. in. to. explain. my. mother. s. behavior. and. walking

proach. the. topic. of. death. say. how. much. cared. for. cared. for. each

what. we. want. to. hear. from. the. Angel. of. Death: peace. and. Joy

r. who. had. Just. died. and. indeed. he. and. his. mother. were. walking. toward

d. upon. your. life. are. the. visitations. true? there. are. only. three.

htenment. scornful. of. those. who. believed. in. siances. and. mediums

licable? the. telephone. rings. and. you. know. who. it. is. before

mother. was. a. kind. of. sur. ther. lived. in. a. house.

hich. he. h and. which. he. knew. was. many. miles. away. was. it

ld. have. fixed starter. turned. on. the. motor. and. con.

small. island. los rented. rooms. in. the. news. of

our. friends. spent. thei playing. charades. and

mans. were. driven. from. b the. knowledge

 ughtered

oo. people. a. the. time. of. David. and. on. entchronicl

dinary. event. that. it. is. mentioned. ino. not. fewer that. could

ed. outside. Jerusalem. and. it. came. to. pass. that. be. a. seraph. and. in. milton s. paradise. lost. he. is. described:

iel, this . prophet. his. sur. his. man. who. walked. hand. in. hand. with

sixty two. years. old. when. he. took. office. in. 522. B. C. and. Dan.

nder. Darius. and. gave

n. such. a. flat. and. factual. everyday. reasonable. way. so. as. to. dis.

receives. more. information. than. he. can. bear. therefore. it. seems

Intuition Rasbnu. the. Angel. of. Justice. and. weighs. the. good. and

room. off. the. floor! she. was. so. a

Bertha. Otoze

2009

FIGURE 65 117

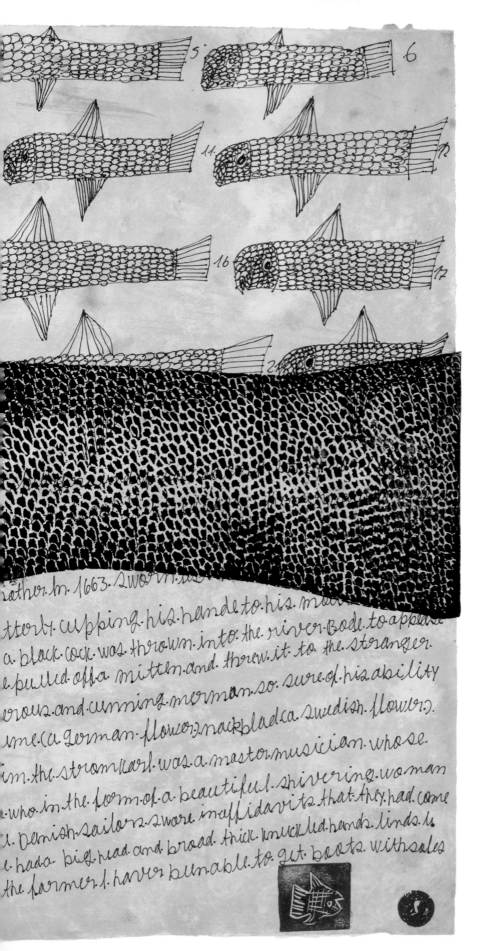

iather. In. 1663. sworn. us.

tterby. cupping. his. hands. to. his. mou
a. black. cock. was. thrown. into. the. river. Bode. to. appease
e. pulled. off. a. mitten. and. threw. it. to. the. stranger.
erous. and. cunning. merman. so. sure. of. his. ability
me. (a. German. flower.) nackbladca. swedish. flower.)
in. the. stromkarl. was. a. master. musician. whose.
who. in. the. form. of. a. beautiful. shivering. woman
Danish. sailors. swore. in. affidavits. that. they. had. come
e. had. a. big. head. and. broad. thick. knuckled. hands. finds. t.
the. farmer. I. have. been. able. to. get. boats. with. sales

FIGURE 66 119

120 FIGURE 67

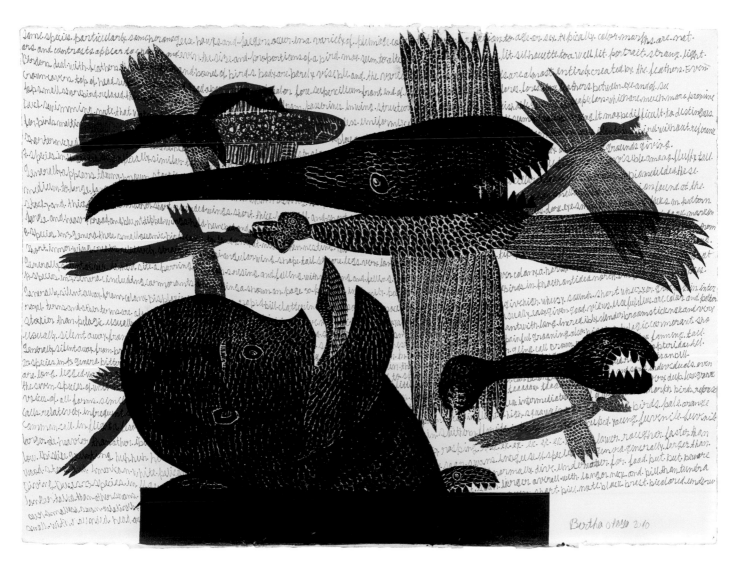

Bertha otoya 2010

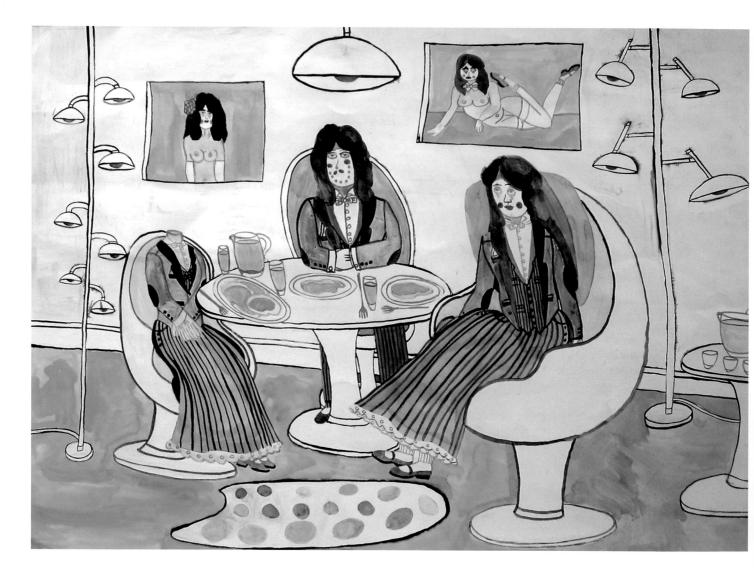

Aurie Ramirez

Writers Arielle Greenberg and Lara Glenum have theorized the "gurlesque," a movement of loosely affiliated female poets who share common ways of thinking. "Gurlesque poets," writes Greenberg, "are unafraid of making poems that seem silly, romantic, or cute; rather, they revel in cuteness, and use it to subversive ends, complicating the relationship between feminism and femininity" ("On the Gurlesque," Small Press Traffic website, April 2003, sptraffic.org). It is this tendency in avant-garde production that comes to mind when I think of Aurie Ramirez, whose flawless doll-like figures live in sixties dollhouse environments with exquisite plastic and chrome furniture and glamorous portraits of themselves on the walls, their attitude at once defiant and affectless.

Ramirez's women, in their exaggerated makeup, have the enigmatic masks of harlequins, but emerging from their frilly net sleeves you can sometimes spy the fists of fury. A great rage simmers under the surface of such paint. There's a California glamour in Ramirez's interiors that is a queer parallel to the Manhattan-centered American Modernism of the Stettheimer sisters. But Ramirez seems somehow more committed. To paraphrase Kenneth Tynan's famous apothegm about Garbo, *What, when drunk, one sees in Florine Stettheimer, one sees in Aurie Ramirez sober.*

FIGURE 68 123

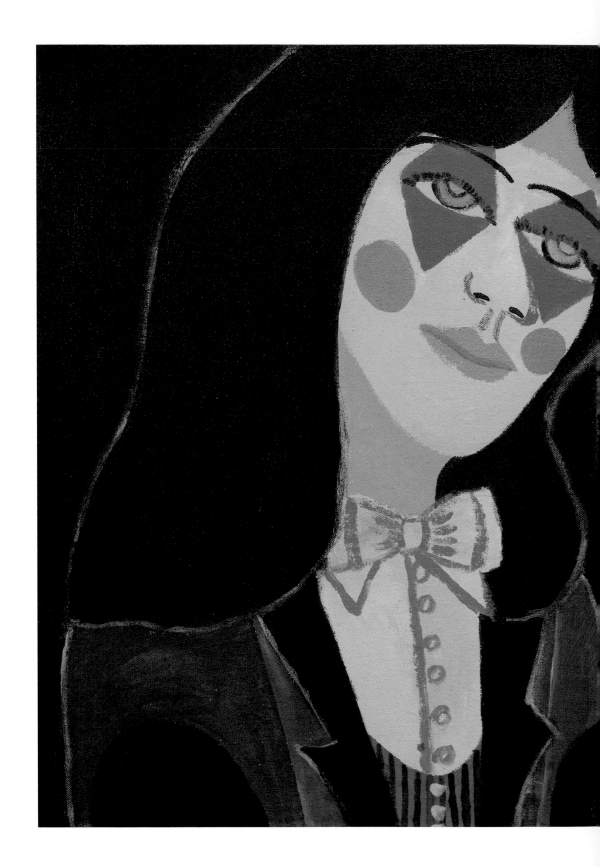

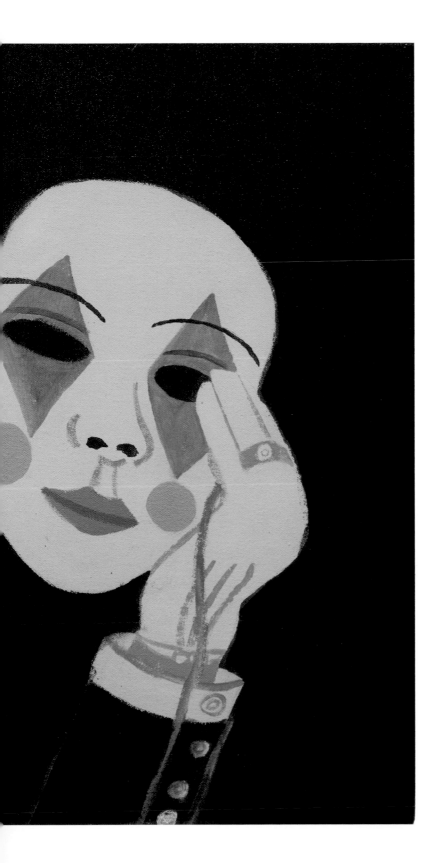

FIGURE 69 125

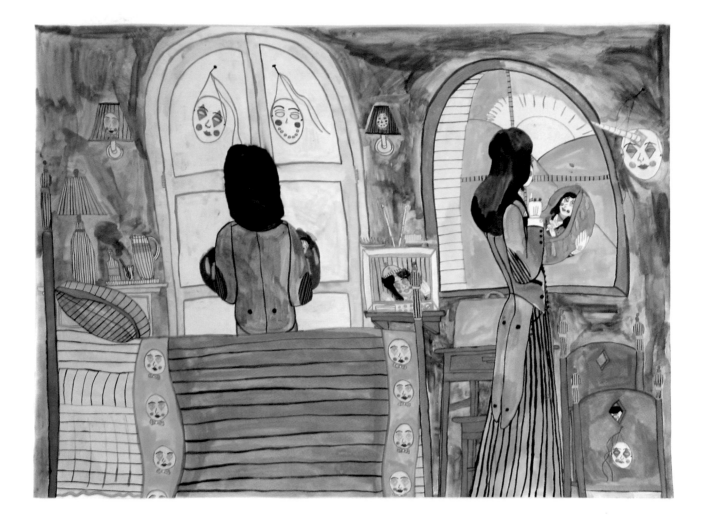

FIGURE 70

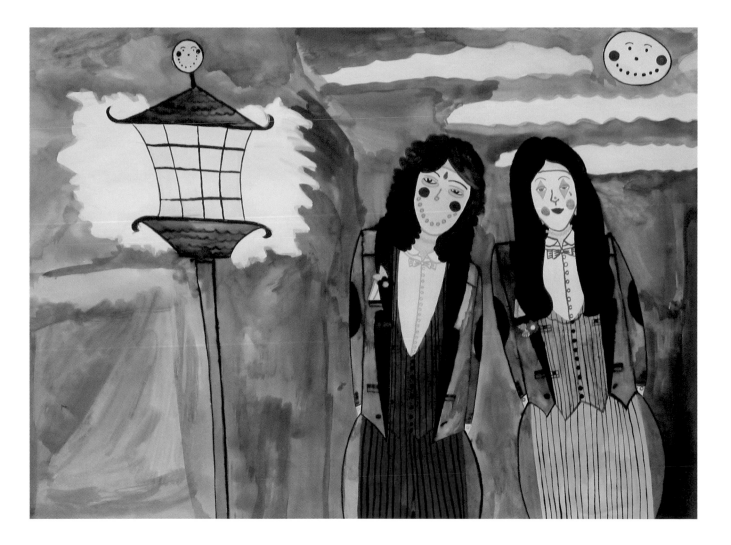

FIGURE 71 127

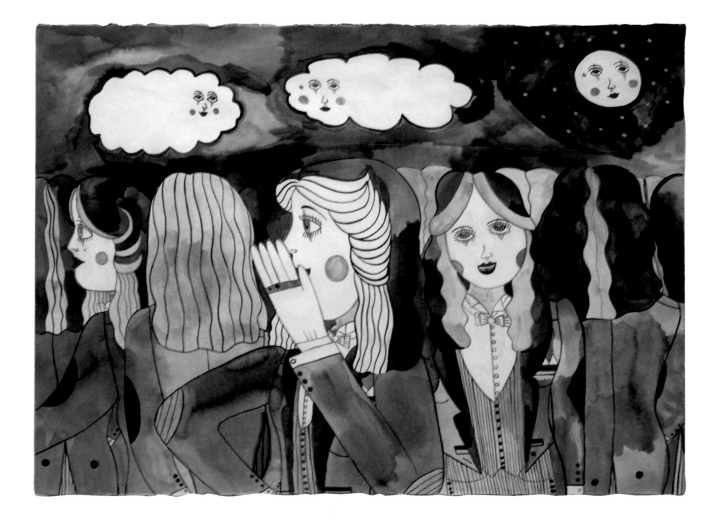

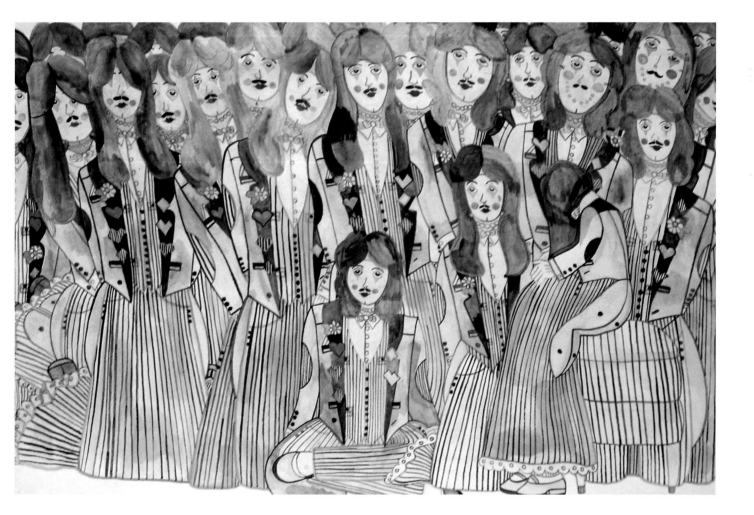

FIGURE 73 129

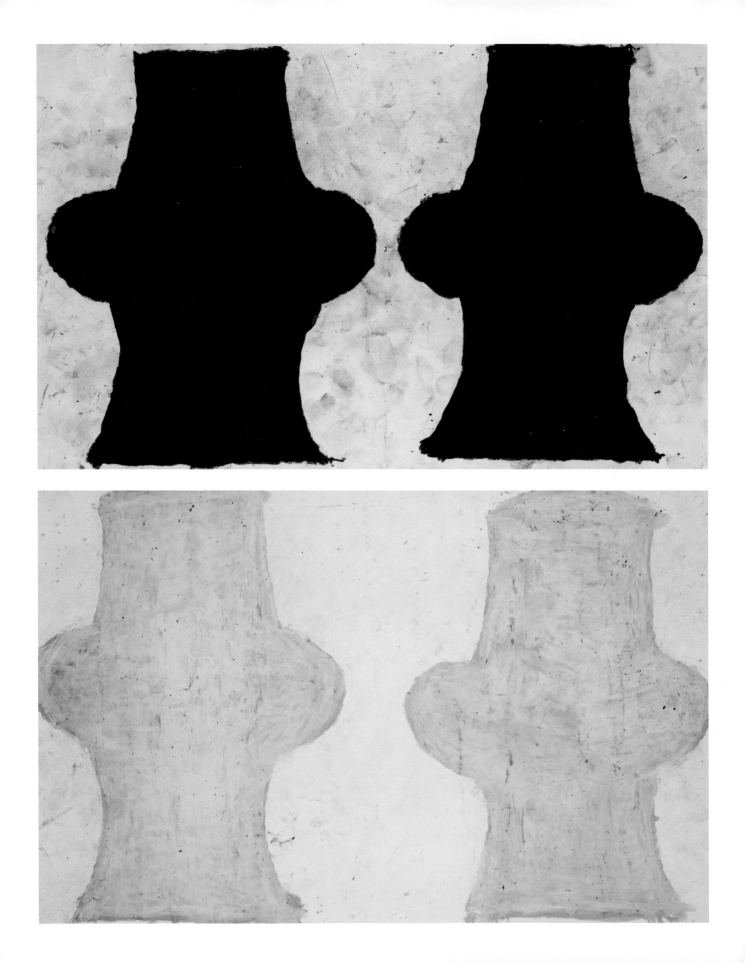

Evelyn Reyes

Evelyn Reyes works almost exclusively in the medium of oil pastel on paper. Her paper is always the same size and, similarly, her subject matter is exceedingly consistent. Over the years she has returned over and over again to a few simple subjects: cakes, garbage cans, and carrots. The simplicity of her approach belies the intensity of her visual effect. Reyes transforms each of her mundane subjects into a bold icon, which she repeats serially though altering the form subtly each time. Her forceful, all-over mark making leads to a densely packed surface in which the oil pastel forms a nuanced patina.

Reyes's cakes occur both singularly and in groups of three (figs. 76–79). In either case, they are strikingly architectural, resembling barns, circus tents, or, perhaps, schoolhouses. Ancillary decorative shapes hover over the uneaten desserts. Her garbage cans take the form of simple, bulbous columns, always in pairs (figs. 74, 75).

Carrots are Reyes's favorite theme (figs. 80–84). Her images of this common vegetable are highly abstracted, sleek capsule-like forms, sometimes accompanied by a short, antenna-like protuberance. Sometimes the carrots are arranged in a crop-like line, but at other times they are composed perpendicularly, creating a strikingly syncopated form. The majority of Reyes's carrots are black or brown, but she has also experimented with a marvelous variety of colors, both for the paper and for the carrots themselves. Reyes asks us to consider the unexpected charm of the domestic, seeing in this often dismissed sphere new worlds of commitment, grandeur, and precision.

FIGURE 74 FIGURE 75 131

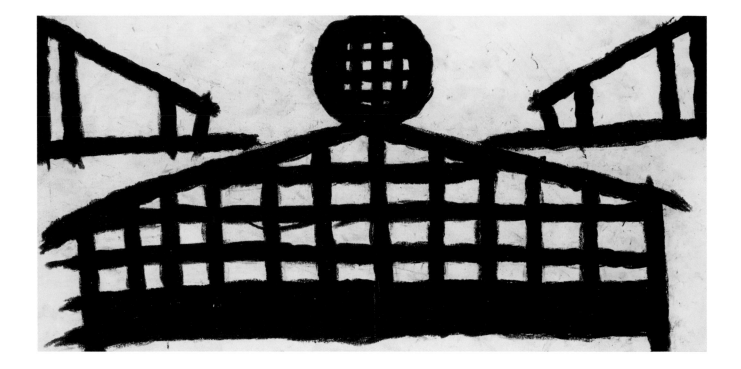

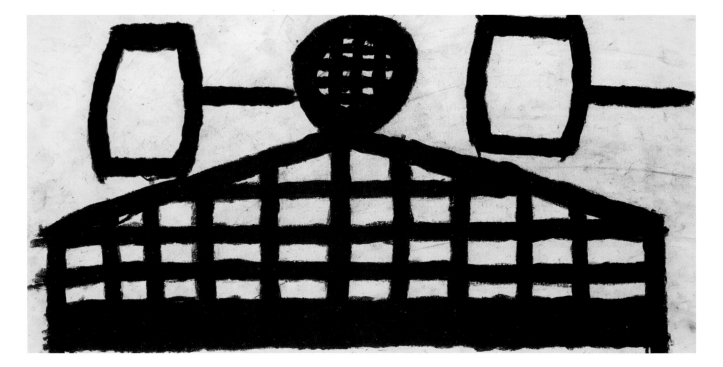

FIGURE 76 FIGURE 77

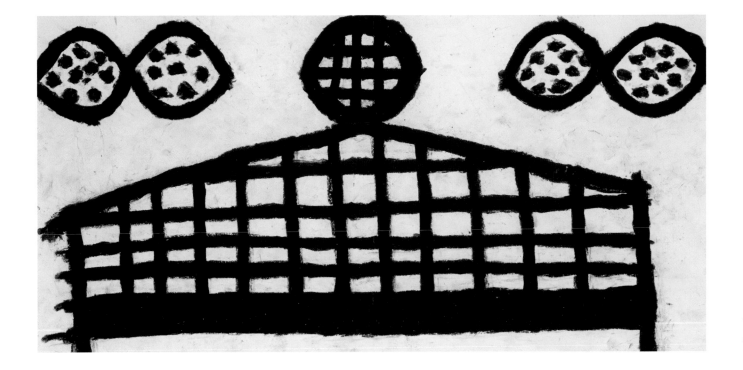

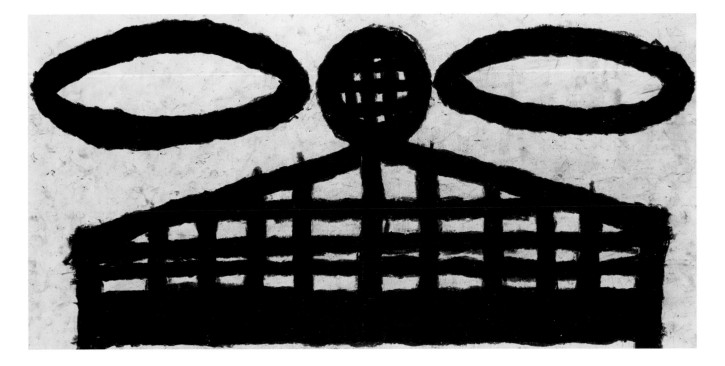

FIGURE 78 FIGURE 79 133

FIGURE 80 FIGURE 81

FIGURE 82 FIGURE 83 135

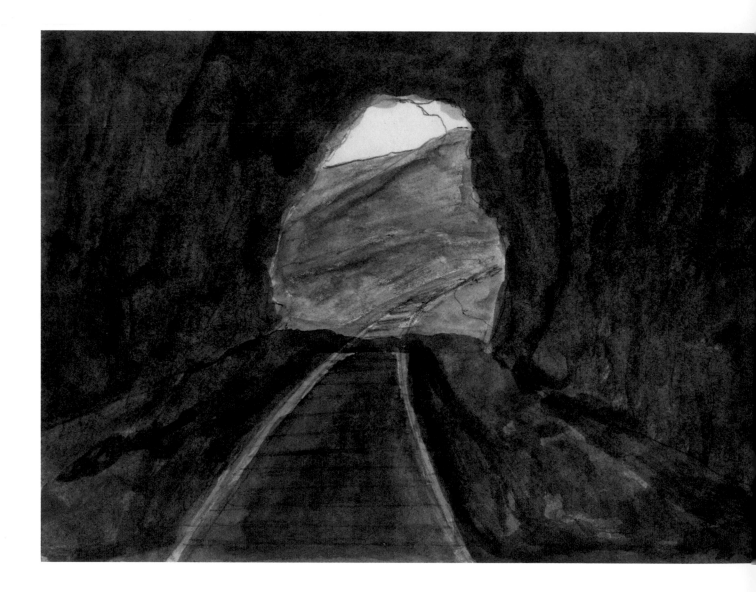

Lance Rivers

There is an uncanny appeal to Lance Rivers's images of bridges, cranes, and tunnels. He has created some astonishing work, and it's hard to name a favorite, but *Train Tunnel Landscape* (2009) (fig. 85), a study of a green ridge and a pale yellow sky appearing round the bend of a stone-hewn tunnel, is probably mine. How august is the pace of the train—the train we never see because, I suppose, we're on it, sketchpad in hand, recording its progress from the engineer's cab. No wonder the cinema makes so many jokes about trains entering tunnels—in a penetrative society penetration is something to be giggled away—and yet how little attention is paid to the train coming out of darkness.

The artist draws from memories of his walks and drives around the Bay Area. In these pieces we can recognize, in striking detail, familiar sites: the Glen Park BART station, the Richmond–San Rafael Bridge, the Posey Tube connecting Alameda to Oakland, and the towering cranes that mark the skyline of the Port of Oakland.

Rivers seems to have an innate sense of perspective that he deploys with virtuosity to create a rushing upward vertigo—even his tunnel images appear to invite us to rise with them into some unknown higher realm.

FIGURE 85 139

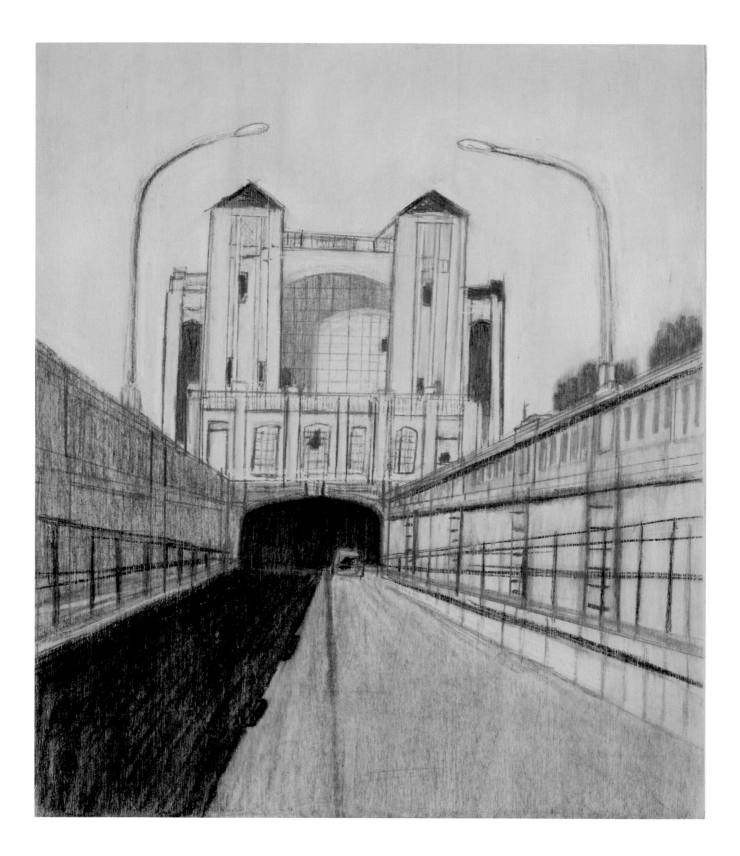

FIGURE 86

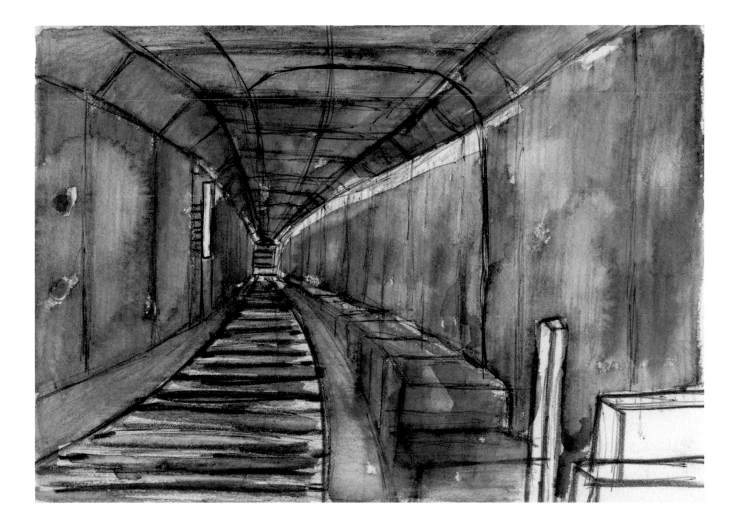

FIGURE 87 141

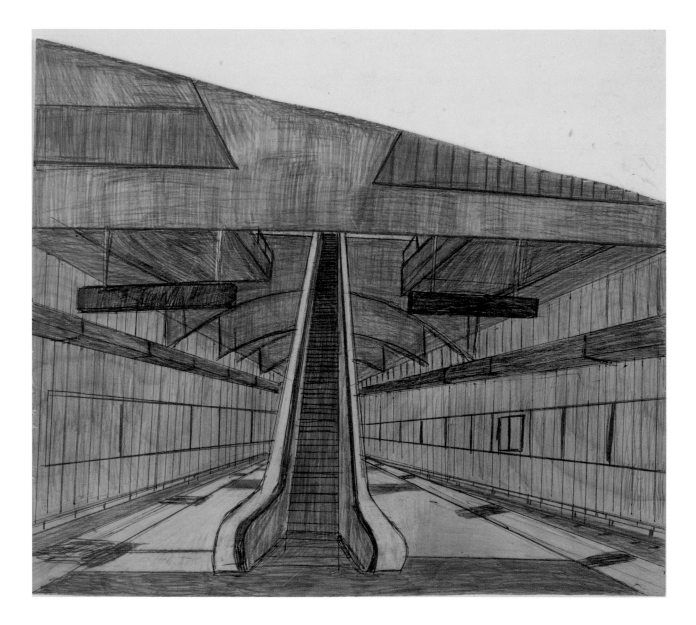

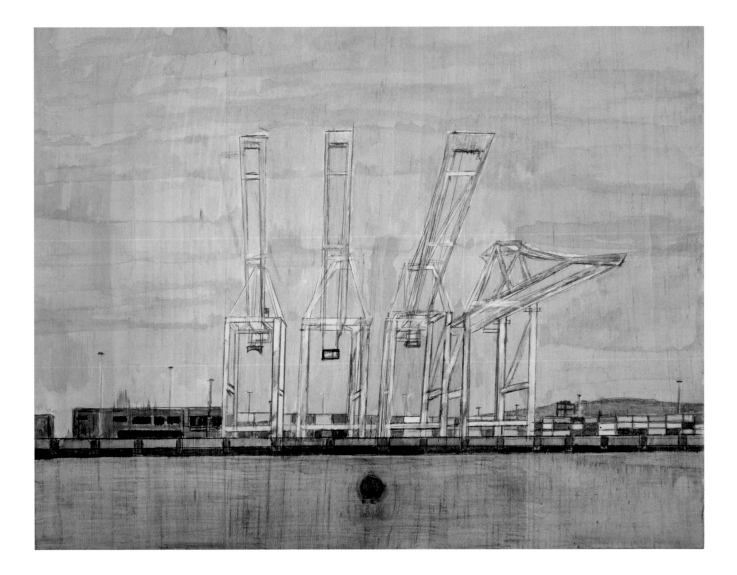

FIGURE 89 FIGURE 90> 143

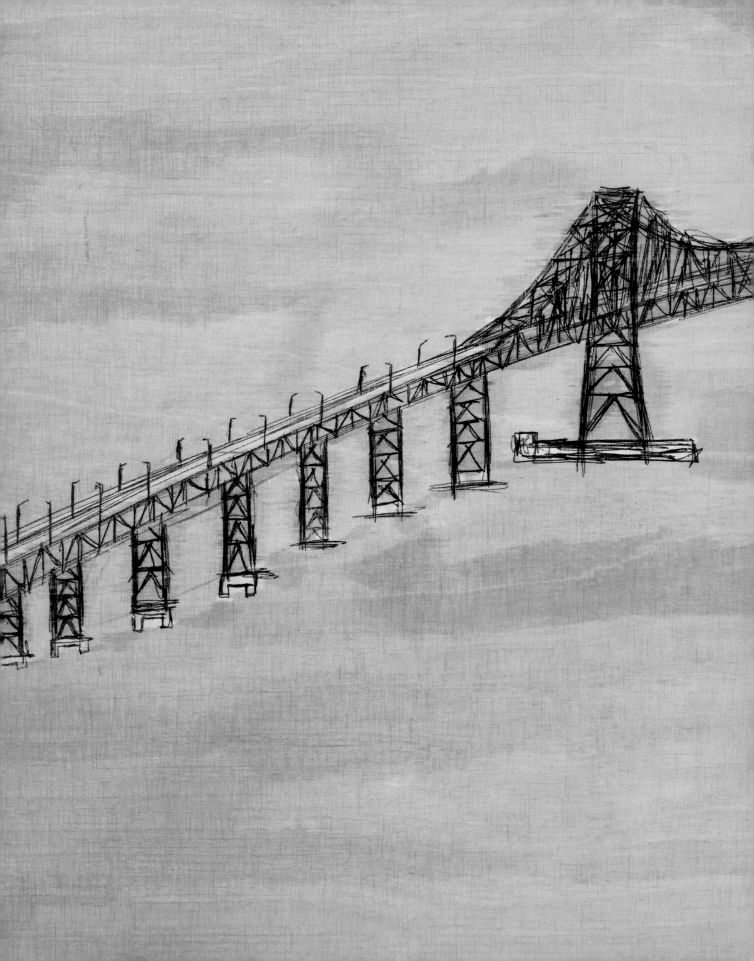

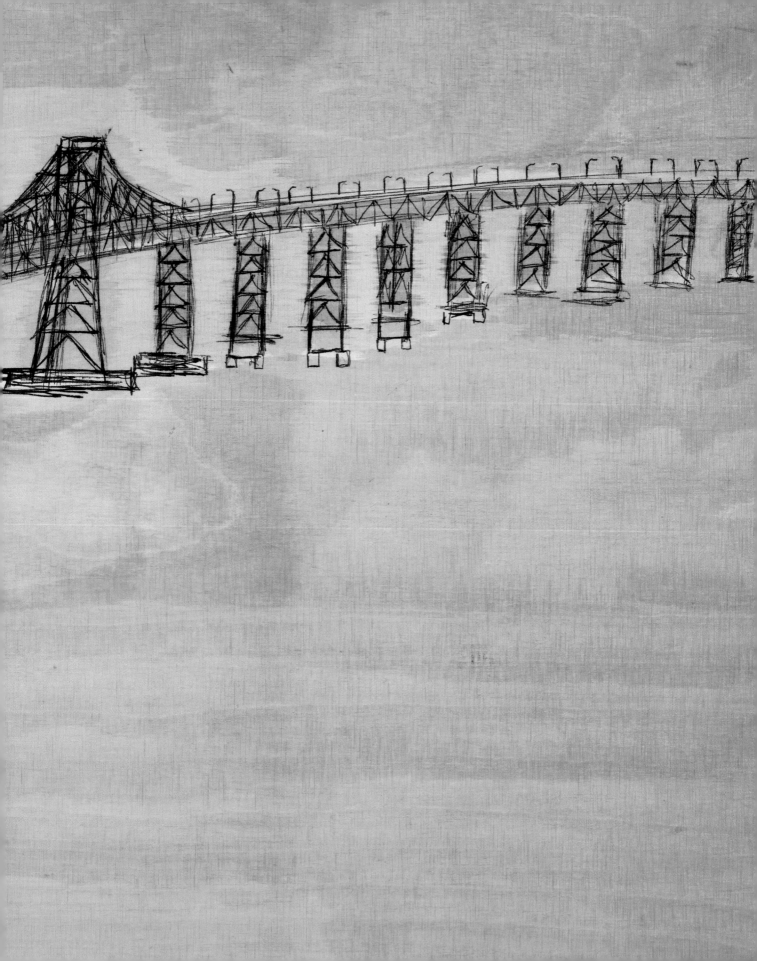

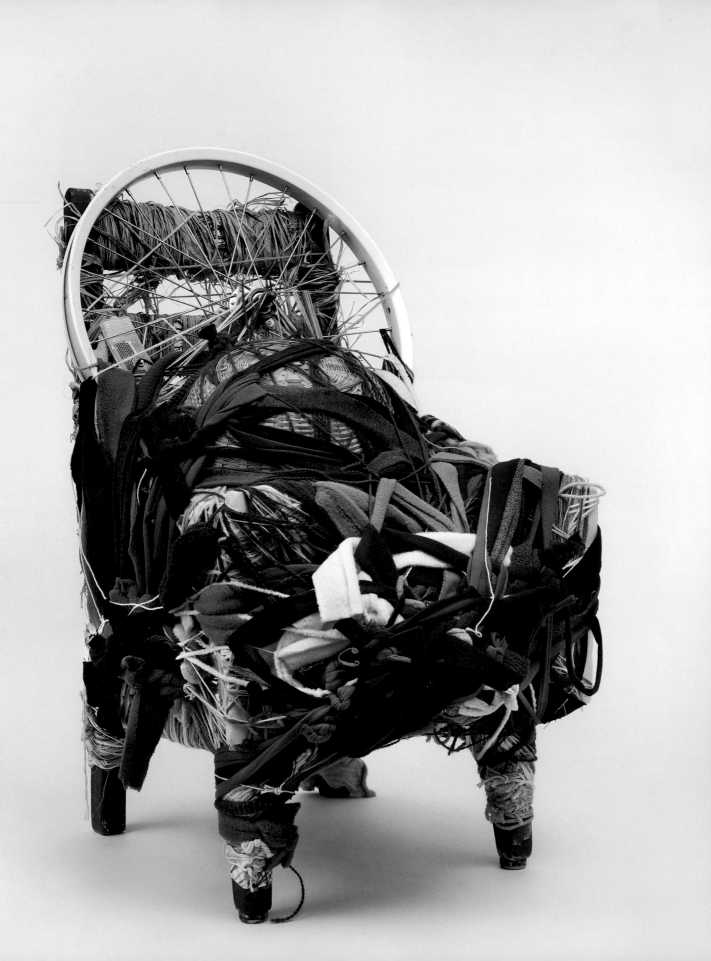

Judith Scott

Shirt cardboard, fiber scraps, bicycle gears, bolts of shiny Mylar, strings of Christmas lights, high heels, CDs, and album covers: everything disappeared inside of Judith Scott's sculptures. People used to joke that every time a load of laundry was done anywhere in the world, all the missing socks went up her sleeve. She was willful, focused, and others responded to that drive in her as they'd responded, a hundred years earlier, to Gertrude Stein. It took each of these innovators decades to win over the world, but once hooked, the world rolled up to their feet and remained there, purring. Stein wrote, "the world is round," and Judith Scott calmly and methodically demonstrated again and again that the capacious baggy monster of the heart had room for all things.

Scott is best known for her wrapped sculptures, which have given art audiences a somewhat denser, more personal counterpoint to the public projects of her contemporaries Jeanne-Claude and Christo. I guess we like wraps for their similarities to the embrace, or for their suggestion of the veil that covers all things until, well, until the rapture. Scott, born with Down syndrome in 1943, spent most of her life institutionalized, until her twin sister Joyce found her and secured her release. Is the work that she produced so furiously an endless rehearsal of love, gratitude, fear, anger, maybe even a horror of dependence, of being beholden? The sculpture gives no clue, but it punches holes in the world that seem to scream out that something vast was here.

FIGURE 91 147

148 FIGURE 92

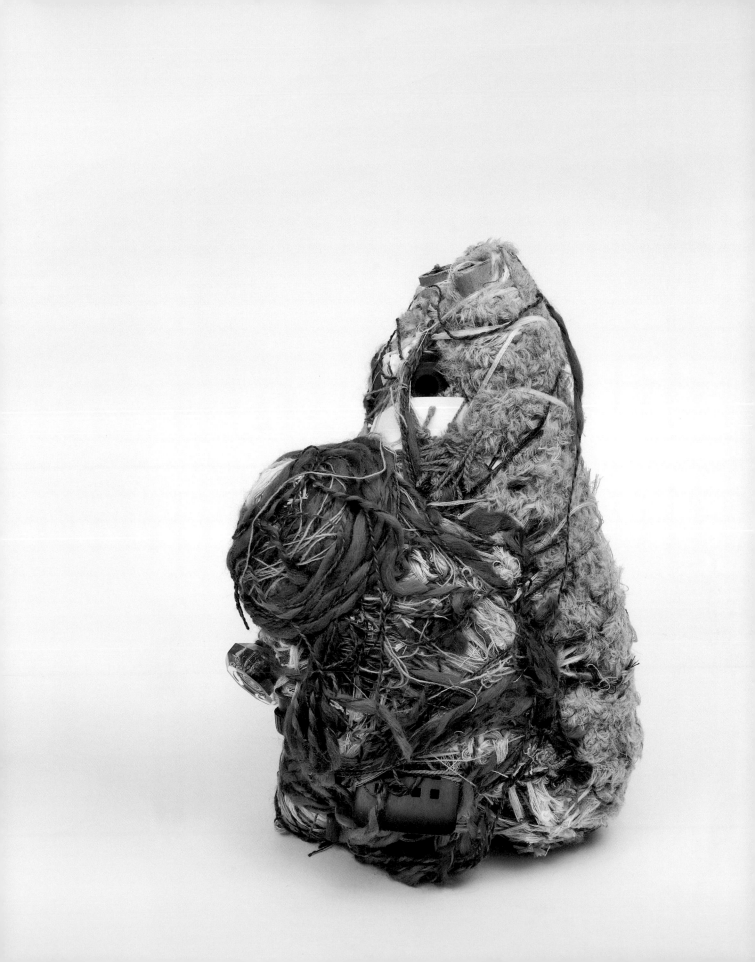

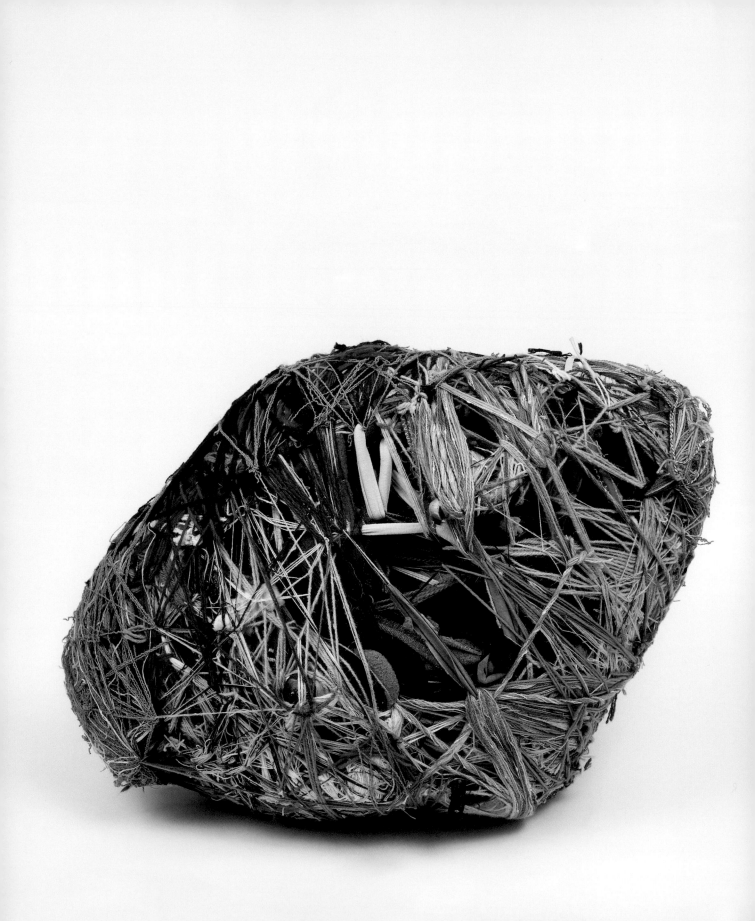

FIGURE 93 151

FIGURE 94

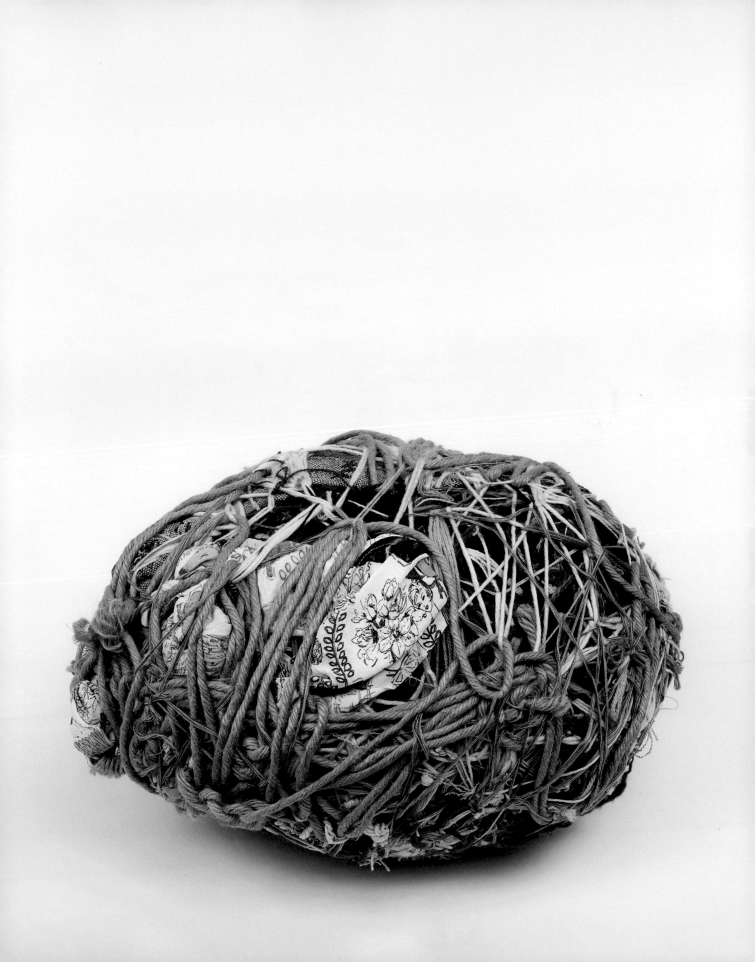

Praise Frisco
at morning

William Scott

William Scott's work comes honestly by its edgy, provocative luster: his proud and gorgeous figures march out from the whole panoply of affirmative post-Reconstruction art initiatives documented by scholar Lisa E. Farrington in her 2004 study *Creating Their Own Image: The History of African-American Women Artists* (New York: Oxford University Press), including WPA mural projects and the Harlem Art Workshop that fostered Jacob Lawrence and Romare Bearden. Scott's people glow with the hip sheen of Mati Klarwein's and Robert Springett's 1970s LP covers for Miles Davis, Graham Central Station, Carlos Santana. Scott's yearning for an African American utopia is quite explicit: his 2005 watercolor and ink rendering of San Francisco's downtown, *Praise Frisco at Morning* (fig. 95), shows us John Winthrop's vision of a "city on a hill" burnished anew for a multicultural generation. In general, his architectural renderings are stunning, filled with deep shadows and the vivid colors Maxfield Parrish used to work so well. San Francisco becomes a city of praise, literally a "gospel town." Scott's drive to refurbish extends right back into the horrors of the twentieth century with an ingenious program to "reinvent the past" to be the person you might have been. Like the younger artist Kehinde Wiley, Scott repositions his figures on the "world stage," as Wiley calls it, relocating the marginal and exceptional of today as princes and angels, saints and kings.

FIGURE 95 155

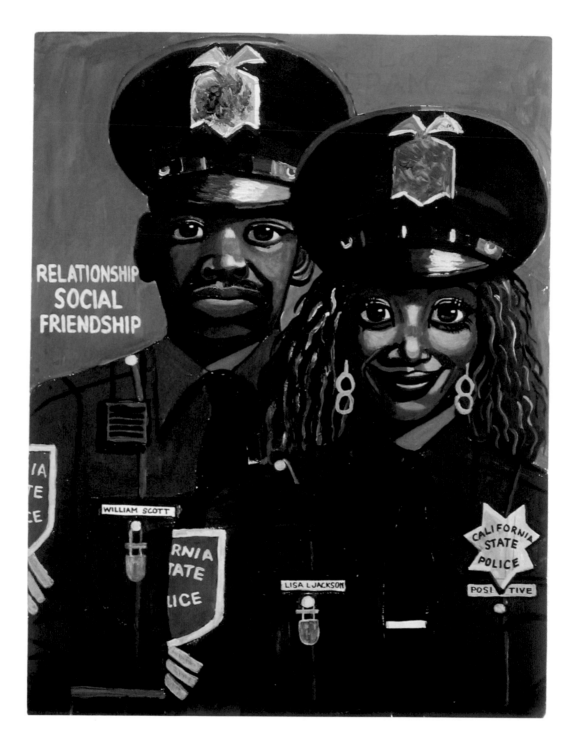

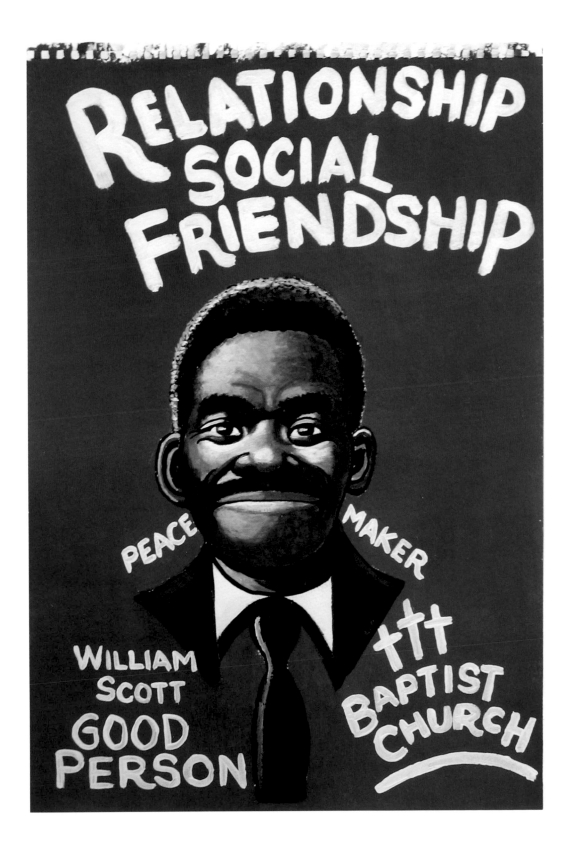

FIGURE 97 157

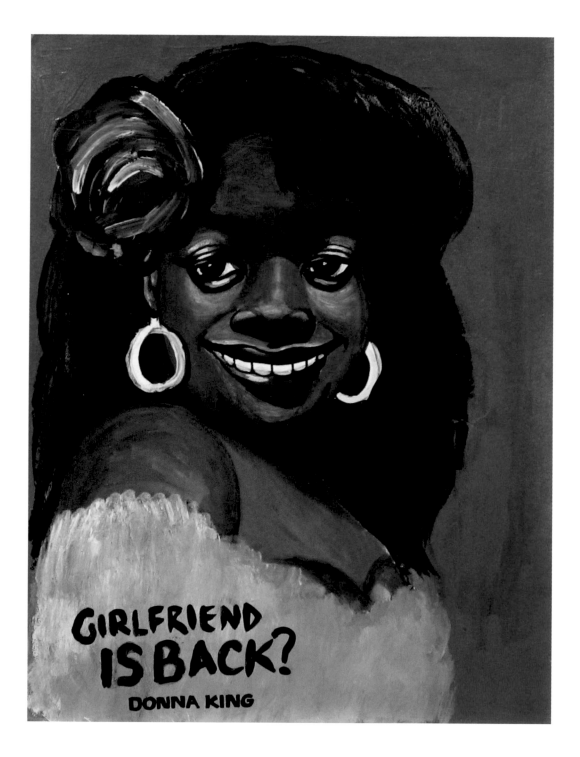

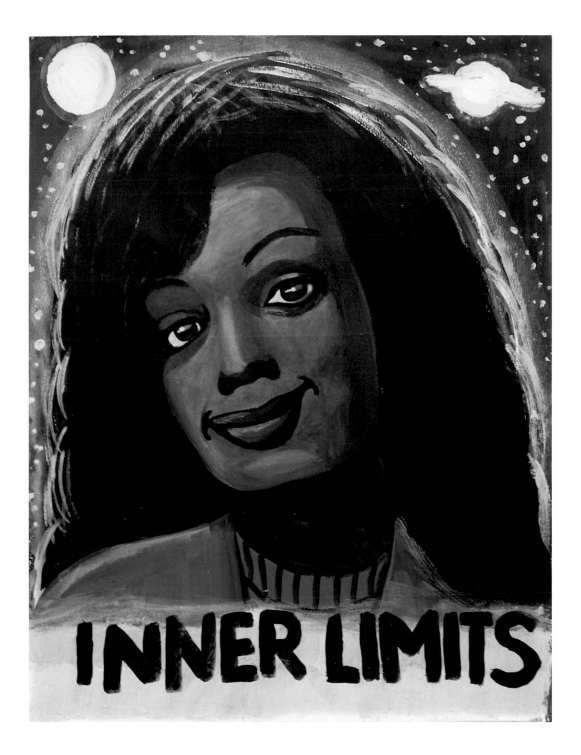

FIGURE 99 159

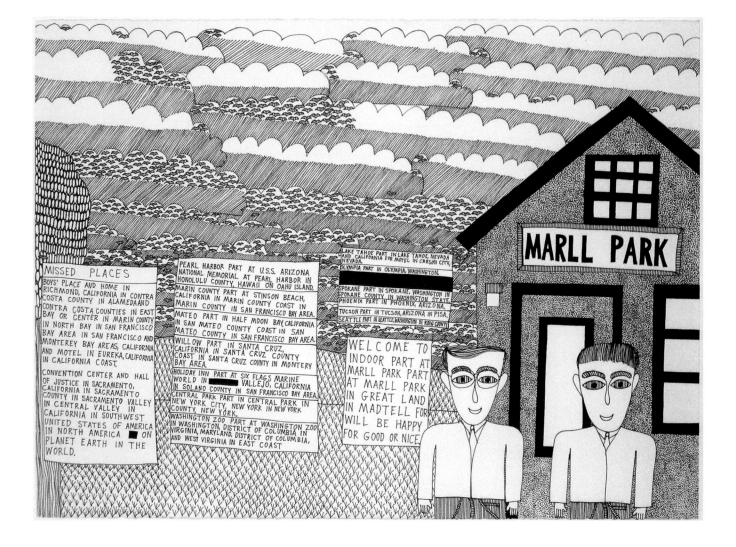

MARLL PARK

MISSED PLACES

BOYS' PLACE AND HOME IN RICHMOND, CALIFORNIA IN CONTRA COSTA COUNTY IN ALAMEDA AND CONTRA COSTA COUNTIES IN EAST BAY OR CENTER IN MARIN COUNTY IN NORTH BAY IN SAN FRANCISCO BAY AREA IN SAN FRANCISCO AND MONTEREY BAY AREAS, CALIFORNIA AND MOTEL IN EUREKA, CALIFORNIA IN CALIFORNIA COAST.

CONVENTION CENTER AND HALL OF JUSTICE IN SACRAMENTO, CALIFORNIA IN SACRAMENTO COUNTY IN SACRAMENTO VALLEY IN CENTRAL VALLEY IN CALIFORNIA IN SOUTHWEST UNITED STATES OF AMERICA IN NORTH AMERICA ■ ON PLANET EARTH IN THE WORLD.

PEARL HARBOR PART AT U.S.S. ARIZONA NATIONAL MEMORIAL AT PEARL HARBOR IN HONOLULU COUNTY, HAWAII ON OAHU ISLAND.
MARIN COUNTY PART AT STINSON BEACH, CALIFORNIA IN MARIN COUNTY COAST IN MARIN COUNTY IN SAN FRANCISCO BAY AREA.
MATEO PART IN HALF MOON BAY, CALIFORNIA IN SAN MATEO COUNTY COAST IN SAN MATEO COUNTY IN SAN FRANCISCO BAY AREA.
WILLOW PART IN SANTA CRUZ, CALIFORNIA IN SANTA CRUZ COUNTY COAST IN SANTA CRUZ COUNTY IN MONTEREY BAY AREA.
HOLIDAY INN PART AT SIX FLAGS MARINE WORLD IN ███████ VALLEJO, CALIFORNIA IN SOLANO COUNTY IN SAN FRANCISCO BAY AREA.
CENTRAL PARK PART IN CENTRAL PARK IN NEW YORK CITY, NEW YORK IN NEW YORK COUNTY, NEW YORK.
WASHINGTON ZOO PART AT WASHINGTON ZOO IN WASHINGTON, DISTRICT OF COLUMBIA IN VIRGINIA, MARYLAND, DISTRICT OF COLUMBIA, AND WEST VIRGINIA IN EAST COAST

LAKE TAHOE PART IN LAKE TAHOE, NEVADA AND CALIFORNIA FOR MOTEL IN CARSON CITY, NEVADA.
OLYMPIA PART IN OLYMPIA, WASHINGTON.
SPOKANE PART IN SPOKANE, WASHINGTON IN SPOKANE COUNTY IN WASHINGTON STATE.
PHOENIX PART IN PHOENIX, ARIZONA.
TUCSON PART IN TUCSON, ARIZONA IN PISA.
SEATTLE PART IN SEATTLE, WASHINGTON IN KING COUNTY.

WELCOME TO INDOOR PART AT MARLL PARK PART AT MARLL PARK IN GREAT LAND IN MADTELL FOR WILL BE HAPPY FOR GOOD OR NICE

William Tyler

William Tyler, like Judith Scott, was born a twin and his brother also became an artist at Creative Growth. You can see the brothers in front of the Marll Park sign in *Untitled (Marll Park)* (2005) (fig. 100) and elsewhere in Tyler's corpus. Tyler has the soul of a documentarian, and much of his most significant work involves leaving evidence behind: a record of the things the twins did, the shirts they wore, the fun times they had. One wears a flattop sort of haircut, the other a wave of bangs and round glasses. Their lives are punctuated by calendars of different sorts: wall calendars, desk calendars, the kind where you tear off one day after another, each new one perfectly fresh and promising. And thermometers mounted on wall brackets, mercury paying his call. And digital clocks.

The legend of Peter Pan is a touchstone for both artists, and especially the figure of Peter Pan's ally/servant/slave/avatar Tinkerbell, described by Tyler in one drawing as the Hermes figure who darts and flickers between worlds: "Tinkerbell she flying from Make Believe Land to this place at this reality to brings a magic wand before make it more." At that time calendars will be abolished; we will see no more of them on planet Earth, whether in kitchens or mess halls, at camps or restaurants or cafés, or pizza and ice cream parlors, or at gift shops in hospitals, the gyms at children's hospitals, or pharmacies.

FIGURE 100 161

MORR BARTMONT FAIR AT MORR BARTMONT FOR DREAMS FOR BAD FUNNY FOR CHRISTMAS, HALLOWEEN, THANKSGIVING, AND EASTER BEFORE DREAMS ARE NO FUN FOR BAD FUNNY BEFORE CAN NOT BELIEVE IT.

BIRTHDAY GIFTS FOR EVERYONES BEFORE WILL BE HAPPY FOR 12 MONTHS IN ONE YEAR FOR BIRTHDAY PARTIES FOR NICE AND GOOD FOODS BOOKS, BOOKS FOR ATLAS, GUILDS, CLOTHES, WATCHES, CARDS, BELTS, SHOES, SUNGLASSES, MAGIC WANDS, AND BOOKLETS FOR WILL BE HAPPY.

BOXT TERMINAL FOR EMERGENCY FOR PINK PAPER. BLACK BIRD AT NIGHT FOR PEOPLE STAYIN HOUSES AND BUILDING FOR GREEN PAPER TO DOCTOR'S OFFICE.

MAGIC SHOW AT MAGICIAN'S HOME FOR STEVE FOR MAGICIAN AND WIZARD FOR MAGICAL POWER FOR GOOD AND NICE BEFORE WILL BE HAPPY AND NOMORE EMPTIES FOR BAD FUNNY.

MEN'S HOME IN KINT CITY, K.W. IN W.R.R.W. CAPITOL COUNTER IN GREAT LAND IN MADTELL ON PLANET EARTHER FOR BOYS, MEN, AND GENTLEMEN AND LID.'S HOME FOR GIRLS, WOMEN, AND LADIES AT KINT CITY, K.W.

L.I.D.'S HOME FOR GIRLS, WOMEN, AND LADIES IN KINT CITY, K.W. IN W.R.R.W. CAPITOL COUNTER IN GREAT LAND IN MADTELL ON PLANET EARTHER.

WELCOME TO MADTELL OCEAN FOR SEAGULLS, SEABIRDS IN THE SKY, AND FISHES, SHARKS, SEAHORSES, WHALES, OCTOPUS, CRABS, LOBSTERS, EELS, AND MANTA RAY DOLPHINS AND JELLYFISHES, SEALS ARE MADTELL OCEAN. SQUIDS ARE IN MADTELL OCEAN. BOATS AND SHIPS ARE MADTELL OCEAN. NO SWIMMING IN MADTELL OCEAN TOO DANGER BEFORE MAKE A RULES AND LAWS.

EVERYONES ARE NEED HELP TO MADTELL CITY FOR PEOPLE FOR MEN, WOMEN, CHILDREN AND KIDS FOR BOYS AND GIRLS FOR BABIES.

ANIMALS ARE NEED HELP AT G.L.S.P.C.A TO MEET MADTELL CITY FOR DOGS, CATS, AND BIRDS AND WILL BE HAPPY FOR CATS, DOGS, AND BIRDS.

HART CENTER AT K.W. 299 AT MADTELL EAST COAST AT W.R.R.W. CAPITOL COUNTER IN GREAT LAND AT MADTELL OR PLACE ON PLANET EARTHER.

MOVE TO ANOTHER PLACE IN ANOTHER PLANET FOR NEW HOME BEFORE WILL BE HAPPY FOR WHITE PAPER FOR GREAT LAND IN MADTELL ON PLANET EARTHER FOR FUTURE TO COMES.

FIGURE 102

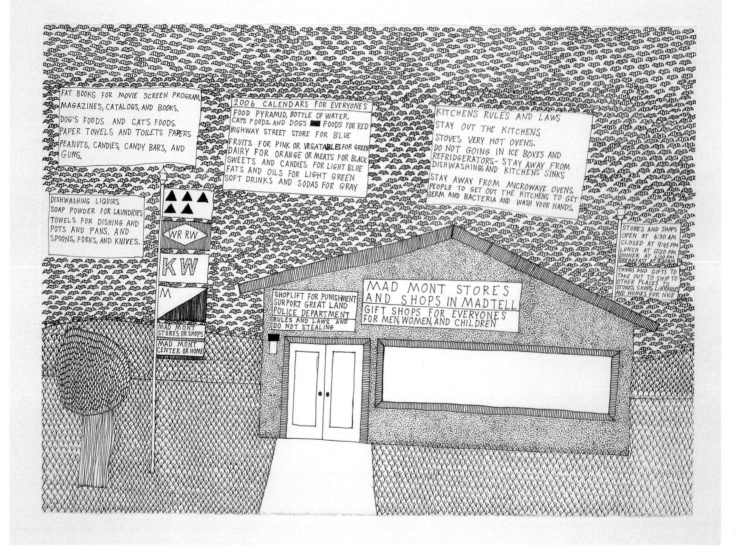

FIGURE 103 165

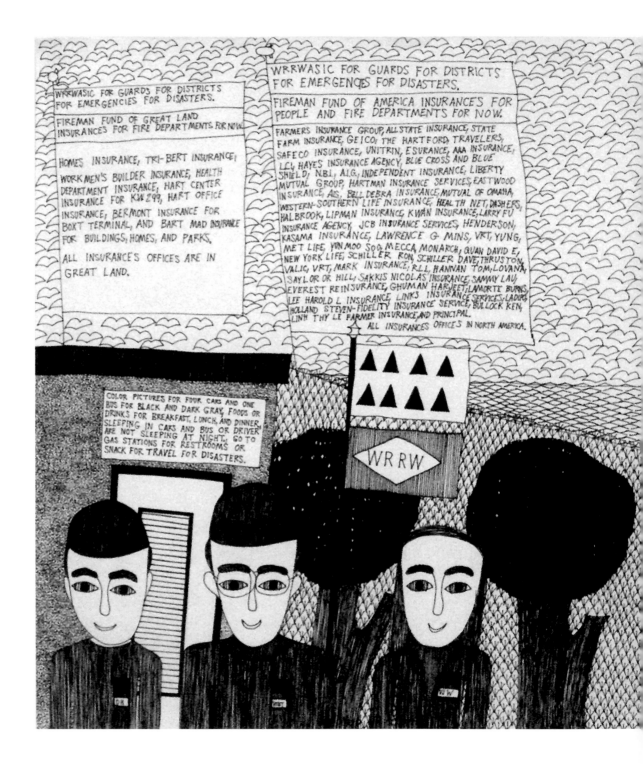

FIGURE 104 167

List of Illustrations

Artists' Biographies

List of Illustrations

Mary Belknap

All works courtesy of the artist and Creativity Explored, San Francisco

1 Untitled, c. 2008; Sharpie marker and felt-tip pen on paper; 25 × 19 ½ in.

2 Untitled, 2006; acrylic on fabric; 27 ¾ × 16 ½ in.

3 Untitled, 2010; ink and watercolor on paper; 20 × 15 in.

4 Untitled, 2010; ink and watercolor on paper; 18 × 14 in.

5 Untitled, 2010; colored pencil, ink, and watercolor on paper; 16 × 20 in.

6 Untitled, 2010; Sharpie marker and felt-tip pen on foam board; 16 ½ × 16 ½ in.

Jeremy Burleson

7 *Syringes*, 2007–8; paper, tape, and marker; approx. 100 syringes at 5 to 16 in. each; installation view: NIAD at 25, November 18, 2008–January 15, 2009, Pro Arts, Oakland. Photo: Brian Stechschulte, NIAD Art Center.

8 *Syringes* and *Lamps*, 2007–8; paper, tape, and marker; 5 to 16 in. each; installation view: NIAD at 25, November 18, 2008–January 15, 2009, Pro Arts, Oakland. Photo: Brian Stechwschulte, NIAD Art Center.

9 *Lamps*, 2007–8; paper, tape, and marker; 160 lamps at 9 to 14 in. each; installation view: NIAD at 25, November 18, 2008–January 15, 2009, Pro Arts, Oakland. Photo: Brian Stechschulte, NIAD Art Center.

10 *Ventilators*, 2007–10; paper, tape, and marker; 3 at 10 to 14 in. each; courtesy of NIAD Art Center, Richmond, CA.

11 *Handcuffs*, 2007–10; paper, tape, and marker; 5 sets at 11 to 15 in. each; courtesy of NIAD Art Center, Richmond, CA.

Attilio Crescenti

All works courtesy of NIAD Art Center, Richmond, CA

12 Untitled, 1986; ink on paper; 17 ¾ × 22 ¾ in.

13 Untitled, March 27, 1986; ink on paper; 23 × 29 in.

14 Untitled, c. 1986; ink on paper; 17 ½ × 22 ½ in.

15 Untitled, c. 1986; ink on paper; approx. 23 × 29 in.

Daniel Green

Unless otherwise noted, all works courtesy of the artist and Creativity Explored, San Francisco

16 *That's the Star Trek*, 2009; colored pencil and ink on recycled wood; 17 ¹³⁄₁₆ × 25 ⅜ in.; Creativity Explored Steele Art Collection.

17 *She Is Naked*, 2009; colored pencil and ballpoint pen on recycled wood; 11 ⅝ × 15 ⅞ in.

18 *Giving the Dance*, c. 2009; ink and colored pencil on recycled wood; 10 ¾ × 13 ⅜ in.

19 *The Baby and the Lady*, 2009; Sharpie marker, colored pencil, ink, and graphite on recycled wood; 11 ⅝ × 15 ⅞ in.

20 *Jesus Tiger, Jesus Men, Man Dog*, 2009; oil pastel and colored pencil on mat board with acrylic and ink; 9 ½ × 6 × 1 in.

Willie Harris

All works courtesy of the artist and NIAD Art Center, Richmond, CA

21 Untitled, 2010; acrylic on fabric and foam acoustic tiles; 13 × 21 × 2 ½ in.

22 Untitled, 2008; acrylic on canvas; 28 × 16 × 2 ½ in.

23 Untitled, 2009; acrylic on canvas; 21 × 65 ½ × 1 in.

24 Untitled, 2010; acrylic on canvas; 12 × 32 × 1 ½ in.

Carl Hendrickson

All works courtesy of Creative Growth Art Center, Oakland
Photos by Benjamin Blackwell

25 Untitled, 2009; wood; 132 × 20 × 24 in.

26 Untitled, 2009; wood with textile; 126 × 35 × 30 in.

27 Untitled, 2010; wood and Plexiglas; 37 × 65 × 29 in.

Michael Bernard Loggins

28, a–f *Fears of Your Life* (front and back covers and selected interior pages), 1995; *Whipper Snapper Nerd* zine; 24 pages; 7 ¹⁄₁₆ × 5 ½ in.; published by Harrell Fletcher and Elizabeth Meyer; courtesy of the artist and Creativity Explored, San Francisco. © Michael Bernard Loggins, reprinted with permission of Manic D Press, San Francisco.

Dwight Mackintosh

All works courtesy of Creative Growth Art Center, Oakland
Photos: Benjamin Blackwell

29 Untitled, 1981; felt pen and tempera on paper; 25 ¾ × 37 ¾ in.

30 Untitled, 1980; felt pen and tempera on paper; 25 ¾ × 37 in.

31 Untitled, 1980; felt pen and tempera on paper; 25 ¾ × 37 ¾ in.

32 Untitled, 1984; felt pen and tempera on paper; 25 × 38 in.

33 Untitled, 1992; felt pen and tempera on paper; 25 × 38 in.

John Patrick McKenzie

Unless otherwise noted, all works courtesy of the artists and Creativity Explored, San Francisco

34 Untitled, 2009; silver marker on paper; 22 × 30 in.; collection of Paul Mugnier and Joe Long, San Francisco.

35 Untitled, 1995; colored pencil and oil pastel on paper; 12 ½ × 19 ¼ in.; collection of Michael McGinnis, San Francisco.

36 Untitled, 2007; Sharpie marker on paper; 20 ¹⁄₁₆ × 32 ½ in.

37 Untitled, 2007; Sharpie marker and collage on paper; 20 × 16 in. Reproduced with permission of the IOC Olympic Museum, Lausanne.

38 *Repetition I*, 2009; Sharpie marker on paper; 8 ½ × 11 in.; collection of Lisa Dawn Colvin and Glenn C. Voorhees, San Francisco.

39 (FRONTISPIECE) *Cirrus Clouds*, 2010; Sharpie marker on Felix Gonzalez-Torres poster; 29 ¼ × 44 ¼ in.

James Miles

Unless otherwise noted, all works courtesy of the artist and Creativity Explored, San Francisco

40 *Men and Plane*, 2006; ink on mat board; 6 ⅜ × 4 ¹³⁄₁₆ in.

41 Untitled, c. 1999; ballpoint pen and acrylic on mat board; 15 ⅞ × 11 ⅞ in.; collection of Amy Auerbach, San Francisco.

42 *James Brown Greatest Hits*, n.d.; acrylic paint and ballpoint pen on foam board; 9 ¹⁵⁄₁₆ × 13 in.; collection of Elizabeth Meyer, Berkeley.

43 Untitled, 1994; colored pencil, watercolor, and ballpoint pen on mat board; 4 ⅞ × 5 ¹¹⁄₁₆ in.; collection of Elizabeth Meyer, Berkeley.

44 *Tiger Cubs*, 2006; Sharpie marker and watercolor on mat board; approx. 4 × 4 in.; collection of Mr. and Mrs. Tim Bremner, San Francisco.

45 *Snack Food Truck*, 2006; liquid acrylic on mat board; 8 × 8 ½ in.

46 *Tom Driving Girls*, 2009; watercolor and ballpoint pen on mat board; 5 ⅛ × 5 in.

47 Untitled, c. 2008; watercolor on paper; 5 ⅛ × 4 ¾ in.; collection of Jack Fischer, San Francisco.

48 *Bookstore*, 2010; India ink on paper; 11 × 13 ⅞ in.

Dan Miller

49 *Untitled (Large Works DM10)*, c. 2010; mixed media on paper; 40 × 60 in.; courtesy Ricco/Maresca Gallery, New York.

50 Untitled, 2006; ink and watercolor on cardstock; 22 ½ × 30 in.; collection of Michael Clifton, New York. Photo: Jean-Marie Guyaux.

51 Untitled, 2006; ink and colored pencil on cardstock; 22 ½ × 30 in.; courtesy of the artist; Creative Growth Art Center, Oakland; and White Columns, New York. Photo: Jean-Marie Guyaux.

52 Untitled, 2006; acrylic and ink on paper; 22 ½ × 30 in.; collection of Adam McEwen, New York. Photo: Jean-Marie Guyaux.

53 *Untitled (Large Works DM6)*, c. 2010; mixed media on paper; 40 × 60 in.; courtesy Ricco/Maresca Gallery, New York.

James Montgomery

All works courtesy of Creativity Explored, San Francisco

54 *Watches on Orange*, 2007; correction fluid pen, ink, and acrylic on paper; 22 × 30 in.

55 *Watches with Leaves*, 2007; correction fluid pen, ink, and acrylic on paper; 22 × 30 in.

56 Untitled, 2007; correction fluid pen, ink, and acrylic on paper; 22 × 29 ½ in.

57 Untitled, 2007; acrylic, ink, and colored pencil on mat board; 19 ¹⁵⁄₁₆ × 25 in.

58 Untitled, 1994; twelve photograms mounted on mat board; 23 ⁵⁄₁₆ × 25 ⁵⁄₁₆ in. overall.

Marlon Mullen

All works courtesy of the artist and NIAD Art Center, Richmond, CA

59 Untitled, 2005–06; acrylic on canvas; 30 × 24 in.

60 Untitled, 2002; acrylic on wood panel; 36 × 42 in.

61 Untitled, 2002; acrylic and gesso on wood panel; 32 ½ × 24 in.

62, a–b Untitled, 2002; acrylic and gesso on wood panel (double sided); 60 × 30 in.

63 Untitled, 2005–06; acrylic and gesso on canvas; 20 × 24 in.

Bertha Otoya

Unless otherwise noted, all works courtesy of the artist and Creativity Explored, San Francisco

64 *Serpiente*, 2010; Sharpie marker and ink wash with acrylic block print on Chinese Celebration paper; 22 × 30 in.

65 *Serpiente*, 2009; Sharpie marker with acrylic block print on paper; 22 × 30 in.

66 *Serpiente*, 2010; Sharpie marker with acrylic block print on paper; 22 ¼ × 30 ⅛ in.

67 *Serpent Beasts II*, 2010; Sharpie marker and ink wash with acrylic block print on paper; 20 × 30 in.; collection of Chris and Gwen Manfrin, Orinda, CA. Photo: Benjamin Blackwell

Aurie Ramirez

68 Untitled, 1999; watercolor and ink on paper; 22 × 30 in.; collection of Martin and Rebecca Eisenberg, New York.

69 Untitled, n.d.; acrylic on canvas; 18 × 24 in.; courtesy of the artist; Creative Growth Art Center, Oakland; and White Columns, New York.

70 Untitled, n.d.; watercolor and ink on paper; 22 × 30 in.; collection of Jeanne Greenberg Rohatyn, New York.

71 Untitled, n.d.; watercolor and ink on paper; 22 × 30 in.; courtesy of the artist; Creative Growth Art Center, Oakland; and White Columns, New York.

72 Untitled, n.d.; watercolor and ink on paper; 22 × 30 in.; collection of Martin and Rebecca Eisenberg, New York.

73 Untitled, 2000; watercolor and ink on paper; 15 × 22 in.; collection of Dave Muller and Ann Faison, Pasadena.

Evelyn Reyes

All works courtesy of the artist and Creativity Explored, San Francisco

74 *Garbage Cans*, 2004; oil pastel on paper; 11 ¼ × 17 ⅝ in.

75 *Garbage Cans*, 2004; oil pastel on paper; 11 ¼ × 17 ½ in.

76 *Cake*, c. 2003; oil pastel on paper; 11 ⅞ × 24 in.

77 *Cake*, c. 2003; oil pastel on paper; 11 ⅞ × 24 in.

78 *Cake*, c. 2003; oil pastel on paper; 11 ⅞ × 24 in.

79 *Cake*, c. 2003; oil pastel on paper; 11 ⅞ × 24 in.

80 *Carrots*, 2009; oil pastel on paper; 10 ¹⁵⁄₁₆ × 15 ¹³⁄₁₆ in.

81 *Carrots*, 2009; oil pastel on paper; 11 ¹⁵⁄₁₆ × 16 ⅜ in.

82 *Carrots*, 2010; oil pastel on paper; 12 × 18 in.

83 *Carrots*, 2007; oil pastel on paper; 11 ¼ × 17 ⁷⁄₁₆ in.

84 *Carrots*, 2008–10; six oil pastel drawings on paper (arranged by Brion Nuda Rosch); 35 ½ × 34 ½ in. overall.

Lance Rivers

85 *Train Tunnel Landscape*, 2009; ink and watercolor on mat board; 5 × 7 in.; collection of Leeza Doriean and John Phillips, San Francisco.

86 *Alameda Tunnel Landscape*, 2010; colored pencil and graphite on wood; 11 × 9 ½ in.; courtesy of the Creativity Explored Steele Art Collection.

87 *Subway Tunnel*, 2009; ink, watercolor, and graphite on mat board; 5 × 7 in.; collection of Leeza Doriean and John Phillips, San Francisco.

88 *Glen Park BART Station Subway*, 2010; Sharpie marker, ink, colored pencil, and graphite on wood; 15 ¼ × 18 in. (irreg.); courtesy of the artist and Creativity Explored, San Francisco.

89 *Port of Oakland Landscape*, 2010; ink and graphite on wood; 13 ⅝ × 17 ⁹⁄₁₆ in.; courtesy of the Creativity Explored Steele Art Collection.

90 *Richmond San Rafael Bridge,* 2010; ink and ballpoint pen on wood; 8 ⁵⁄₁₆ × 14 ½ in.; courtesy of the artist and Creativity Explored, San Francisco.

Judith Scott

All works courtesy of Creative Growth Art Center, Oakland

91 Untitled, 2004; mixed media sculpture; 29 × 16 × 21 in.

92 Untitled, 2003; mixed media sculpture; 19 × 8 × 9 in.

93 Untitled, 2002; mixed media sculpture; 16 × 31 × 14 in.

94 Untitled, 2003; mixed media sculpture; 10 × 20 × 16 in.

William Scott

95 *Praise Frisco at Morning*, 2005; watercolor and ink on paper; 11 ¾ × 15 ½ in.; private collection, New York.

96 *California State Police*, 2002; acrylic on paper; 20 × 15 in.; collection of Matt Murphy, New York.

97 *Good Person (Self-Portrait)*, 2003; acrylic and ink on paper; 18 × 12 in.; collection of Martin and Rebecca Eisenberg, New York.

98 *Girlfriend Is Back (Donna King)*, n.d.; acrylic on paper; 20 × 15 in.; collection of Cindy Sherman, New York.

99 *Inner Limits*, n.d.; acrylic on paper; 20 × 15 in.; collection of David Byrne, New York.

William Tyler

All works courtesy of the artist; Creative Growth Art Center, Oakland; and White Columns, New York

100 *Untitled (Marll Park)*, June 14, 2005; ink on paper; 22 × 30 in.

101 Untitled, September 2, 2005; ink on paper; 22 × 30 in.

102 Untitled, May 24, 2005; ink on paper; 22 × 30 in.

103 Untitled, January 3, 2006; ink on paper; 22 ¼ × 30 in.

104 Untitled, November 14, 2007; ink on paper; 22 ⅜ × 30 in.

Artists' Biographies

Mary Belknap

United States, born 1944
Creativity Explored, San Francisco

SELECTED GROUP EXHIBITIONS
And Then . . . , Creativity Explored, San Francisco, 2010
Paper! Awesome!, Baer Ridgeway Exhibitions, San Francisco, 2010
Art Repurposed, Thoreau Gallery, Thoreau Center for Sustainability, San Francisco, 2009
Compelled to Create, Arts Benicia Gallery, Benicia, CA, 2005
Spirits and Saints, Creativity Explored, San Francisco, 2004

Jeremy Burleson

United States, born 1981
NIAD Art Center, Richmond, CA

SELECTED GROUP EXHIBITIONS
NIAD at 25, Pro Arts, Oakland, 2009
Outsider Art: The Creative Necessity, Sonoma Valley Museum of Art, Sonoma, CA, 2006

Attilio Crescenti

United States, 1925–1988
NIAD Art Center, Richmond, CA

SELECTED GROUP EXHIBITIONS
NIAD at 25, Pro Arts, Oakland, 2009
Fascinated with Faces, The Ames Gallery, Berkeley, 2005

Daniel Green

United States, born 1985
Creativity Explored, San Francisco

SELECTED GROUP EXHIBITIONS
Words, Verses & Garabatos, City College of San Francisco, 2010
APAture 2009: A Spotlight on Asian Pacific American Art, Go For a Loop Gallery, San Francisco, 2009
one of these does not belong, Adobe Books Backroom Gallery, San Francisco, 2008
Seeing Memory, Creativity Explored, San Francisco, 2007
XTOWN2NE, NIAD Art Center, Richmond, CA, 2006
Sacred Places, Creativity Explored, San Francisco, 2006

Willie Harris

United States, born 1956
NIAD Art Center, Richmond, CA

SELECTED GROUP EXHIBITIONS
Life of the World to Come: Twist and Crawl, NIAD Art Center, Richmond, CA, 2011
Rare & Unreleased, NIAD Art Center, Richmond, CA, 2010
NIAD at 25, Pro Arts, Oakland, 2009
Fascinated with Faces, The Ames Gallery, Berkeley, 2005

Carl Hendrickson

United States, born 1951
Creative Growth Art Center, Oakland

SELECTED GROUP EXHIBITIONS
Constructed, Creative Growth Art Center, Oakland, 2008
Creative Growth, Gavin Brown's enterprise, New York, 2007

Michael Bernard Loggins

United States, born 1961
Creativity Explored, San Francisco

SELECTED GROUP EXHIBITIONS
Ritual/Habitual: Linking Object, Context, and Action, Creativity Explored, San Francisco, 2010
Terror?, Intersection for the Arts, San Francisco, 2006
Psst, Hey! Be Mine?, The Chatterbox, San Francisco, 2004
Ten by Twenty, Yerba Buena Center for the Arts, San Francisco, 2004
Don't Call Me Retard, Jewett Gallery, San Francisco Main Public Library, 2004

Dwight Mackintosh

United States, 1906–1999
Creative Growth Art Center, Oakland

SELECTED GROUP EXHIBITIONS
In the House, Madmusée, Liège, Belgium, 2010
Revealing the Human, Arts Project Australia, Northcote Victoria, Australia, 2009
Creative Growth, Galerie Giti Nourbakhsch, Berlin, 2009
Communication Breakdown, Galerie Impaire, Paris, 2008
Creative Growth, Gavin Brown's enterprise, New York, 2007
Creative Growth Art Center, abcd la galerie, Montreuil, France, 2007

John Patrick McKenzie

United States, born Philippines, 1962
Creativity Explored, San Francisco

SOLO EXHIBITION
John Patrick McKenzie's Famous Artworks, Brett McDowell Gallery, Dunedin, New Zealand, 2009

SELECTED GROUP EXHIBITIONS
Paper! Awesome!, Baer Ridgeway Exhibitions, San Francisco, 2010
Collected Fragments, Sunderland Museum & Winter Gardens, Sunderland, England, 2009–10
Bay Area Currents 2009, Pro Arts, Oakland, 2009
Without Borders: Outsider Art in an Antipodean Context, Monash University Museum of Art, Victoria, Australia, 2008
Compelled to Create, Arts Benicia Gallery, Benicia, CA, 2005
Outside Insight: Select Works from the Studios of Creativity Explored and Creative Growth, Graduate Theological Union Library, Berkeley, 2004

James Miles

United States, born 1957
Creativity Explored, San Francisco

SELECTED GROUP EXHIBITIONS

Where Are We?, Creativity Explored, San Francisco, 2010

Songs from the Treetops, PDX Contemporary Art, Portland, OR, 2009

one of these does not belong, Adobe Books Backroom Gallery, San Francisco, 2008

access/ABILITY, Bay Area Discovery Museum, Sausalito, CA, 2007

This Container Isn't Big Enough (in collaboration with Harrell Fletcher), Whitney Museum of American Art, New York, 2004

Radiant Spaces: Private Domain, Track 16 Gallery, Santa Monica, CA, and Irvine Fine Arts Center, Irvine, CA, 2004

Dan Miller

United States, born 1961
Creative Growth Art Center, Oakland

SOLO EXHIBITIONS

Dan Miller: Large Drawings, Ricco/Maresca Gallery, New York, 2010

Dan Miller, White Columns, New York, 2007

SELECTED GROUP EXHIBITIONS

In the House, Madmusée, Liège, Belgium, 2010

Creative Growth, Galerie Giti Nourbakhsch, Berlin, 2009

Glossolalia: Languages of Drawing, Museum of Modern Art, New York, 2008

Creative Growth, Gavin Brown's enterprise, New York, 2007

Creative Growth Art Center, abcd la galerie, Montreuil, France, 2007

Visionary Output: Work by Creative Growth Artists, Rena Bransten Gallery, San Francisco, 2006

Leon Borensztein and His Friends: A Look at Creative Growth Artists and Their Work, Yerba Buena Center for the Arts, San Francisco, 2005

James Montgomery

United States, 1936–2008
Creativity Explored, San Francisco

SOLO EXHIBITION

James Montgomery: It's About Time, California Institute of Integral Studies, Minna Street Center, San Francisco, 2008

SELECTED GROUP EXHIBITIONS

Transmission, Creativity Explored, San Francisco, 2007

Seeing Memory, Creativity Explored, San Francisco, 2007

Marlon Mullen

United States, born 1963
NIAD Art Center, Richmond, CA

SELECTED SOLO EXHIBITION

Marlon Mullen: Paintings, Jack Fischer Gallery, San Francisco, 2007

SELECTED GROUP EXHIBITIONS

Rare & Unreleased, NIAD Art Center, Richmond, CA, 2010

Getting There, NIAD Art Center, Richmond, CA, 2005

The Amazing World of NIAD Art Center, Concourse Gallery, San Francisco, 2005

Bertha Otoya

United States, born Peru, 1979
Creativity Explored, San Francisco

SELECTED GROUP EXHIBITIONS

Visions of Paradise: Art & the Power of Faith, Sonoma Valley Museum of Art, Sonoma, CA, 2010

Text'o-&-Figura, Galería Nacional, Museo de los Niños, San Jose, Costa Rica and Meridian Gallery, San Francisco, 2010

Santos y Otros Creatures, Creativity Explored, San Francisco, 2010

Words, Verses, & Garabatos, City College of San Francisco, 2010

Prints Byte: The cutting edge of printmaking, SOMArts, San Francisco, 2008

Aurie Ramirez

United States, born Philippines, 1962
Creative Growth Art Center, Oakland

SELECTED SOLO EXHIBITIONS

Aurie Ramirez, Jack Hanley Gallery, Los Angeles, 2007

Aurie Ramirez, White Columns, New York, 2005

SELECTED GROUP EXHIBITIONS

In the House, Madmusée, Liège, Belgium, 2010

Revealing the Human, Arts Project Australia, Northcote Victoria, Australia, 2009

Creative Growth, Galerie Giti Nourbakhsch, Berlin, 2009

Creative Growth, Gavin Brown's enterprise, New York, 2007

Creative Growth Art Center, abcd la galerie, Montreuil, France, 2007

Visionary Output: Work by Creative Growth Artists, Rena Bransten Gallery, San Francisco, 2006

Evelyn Reyes

United States, born 1957
Creativity Explored, San Francisco

SELECTED GROUP EXHIBITIONS

Words, Verses, & Garabatos, City College of San Francisco, 2010

Paper! Awesome!, Baer Ridgeway Exhibitions, San Francisco, 2010

Legend: Myth and Memory, Creativity Explored, San Francisco, 2009

Form+, Meridian Gallery, San Francisco, 2008

Delicious, Studio Gallery, San Francisco, 2006

Lance Rivers

United States, born 1967
Creativity Explored, San Francisco

SELECTED GROUP EXHIBITIONS

Ritual/Habitual: Linking Object, Context, and Action, Creativity Explored, San Francisco, 2010

Tasty, Creativity Explored, San Francisco, 2008

You Are Here, Creativity Explored, San Francisco, 2004

Judith Scott

United States, 1943–2005
Creative Growth Art Center, Oakland

SELECTED SOLO EXHIBITIONS

Judith Scott, Ricco/Maresca Gallery, New York, 2001

SELECTED GROUP EXHIBITIONS

Creative Growth, Galerie Giti Nourbakhsch, Berlin, 2009

Constructed, Creative Growth Art Center, Oakland, 2008

Creative Growth, Gavin Brown's enterprise, New York, 2007

Creative Growth Art Center, abcd la galerie, Montreuil, France, 2007

Leon Borensztein and His Friends: A Look at Creative Growth Artists and Their Work, Yerba Buena Center for the Arts, San Francisco, 2005

William Scott

United States, born 1964
Creative Growth Art Center, Oakland

SELECTED SOLO EXHIBITIONS

William Scott—Good Person, White Columns, New York, 2009

William Scott, Galerie Impaire, Paris, 2008

William Scott, White Columns, New York, 2006

SELECTED GROUP EXHIBITIONS

From One Revolution to Another: Carte Blanche to Jeremy Deller, Palais de Tokyo, Paris, 2008–09

Creative Growth, Gavin Brown's enterprise, New York, 2007

Visionary Output: Work by Creative Growth Artists, Rena Bransten Gallery, San Francisco, 2006

William Tyler

United States, born 1954
Creative Growth Art Center, Oakland

SELECTED GROUP EXHIBITIONS

Creative Growth, Galerie Giti Nourbakhsch, Berlin, 2009

Creative Growth, Gavin Brown's enterprise, New York, 2007

Visionary Output: Work by Creative Growth Artists, Rena Bransten Gallery, San Francisco, 2006

Leon Borensztein and His Friends: A Look at Creative Growth Artists and Their Work, Yerba Buena Center for the Arts, San Francisco, 2005

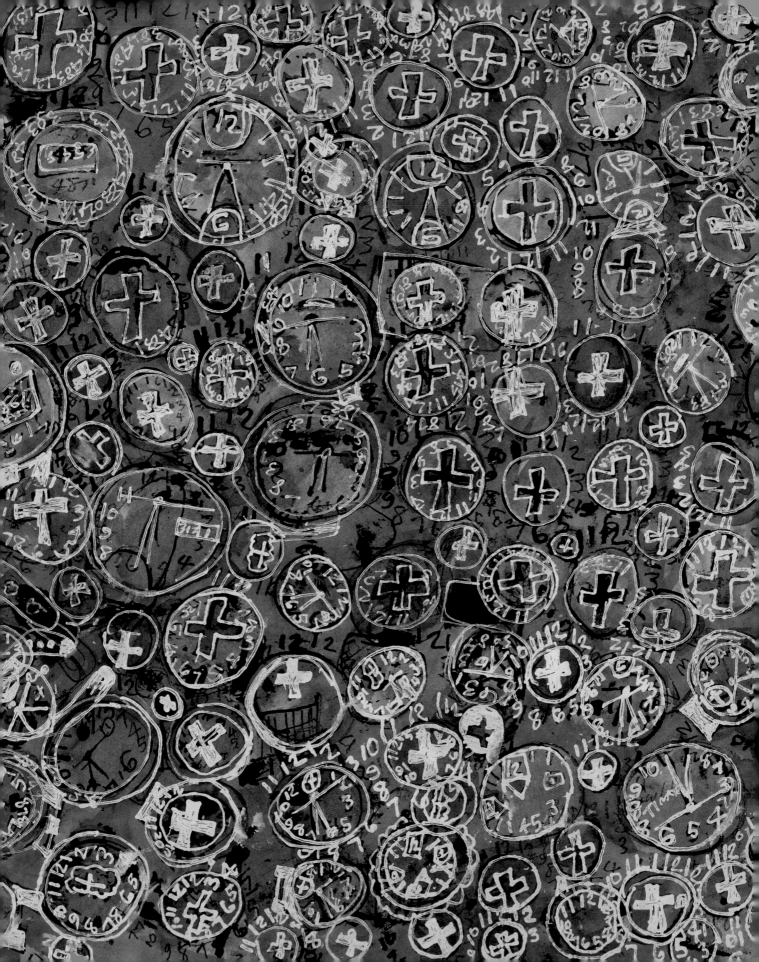